D1598169

Possibility

POSSIBILITY

Essays Against Despair

Patricia Vigderman

Sarabande Books

LOUISVILLE, KENTUCKY

Library of Congress Cataloging-in-Publication Data

Vigderman, Patricia.
 Possibility : essays against despair / Patricia Vigderman. — 1st ed.
 p. cm.
 ISBN 978-1-936747-54-2 (pbk. : acid-free paper)
 I. Title.

PS3622.I458P67 2013
814'.6—dc23

 2012037009

Cover art:
Title: Ocean Ladders
Artist: Joy Umali (joyumali.com)
Photo: Walter Kitundu (birdlightwind.com)

Cover and text design by Kirkby Gann Tittle.

Manufactured in Canada.
This book is printed on acid-free paper.

Sarabande Books is a nonprofit literary organization.

This project is supported in part by an award from the National
Endowment for the Arts.

The Kentucky Arts Council, the state arts agency, supports
Sarabande Books with state tax dollars and federal funding from
the National Endowment for the Arts.

For

Noah and Sophie

CONTENTS

Introduction

Seeing Double

THE LIST OF WORDS my online dictionary offers as rhymes for "despair" are unexpectedly funny: antbear, armchair, carfare, outthere, knitwear, Molière and Poor Clare; shank's mare, mohair, light air, outstare, threadbare, stemware. Health care and high chair. The effort to be helpful is almost touching in its cultural contortions, its eagerness to offer a multiplicity of alternatives to the stumped rhymster. Ranging the Internet from the aardvark (in case, like my spellchecker, you were wondering what an antbear is) to Voltaire, the suggested accompaniments to despair suggest a world of comic juxtaposition, a freedom in language that would make even wheelchair and warfare into occasions for playful possibility, and for curiosity about the world itself. Dress me in loungewear, pour me some Sancerre, take me to Mayfair, and, uh, what exactly is a sea hare? Meanwhile, despair itself remains just a plain small thing, with its negative prefix assaulting hope, a sad little frontal attack on faith.

Nevertheless, there it is, plunking itself into life with or without rhyme or reason. These essays, written over the course of a decade, have been a kind of spontaneous reaction to that presence, to its, OK, *daymare*. They have been translations of life's disordered discoveries into the formal pleasure of language, and evoked for me Walter

1

Benjamin's lonely image of translation itself: a calling into the dark forest of language, seeking in the new language a sympathetic resonance with the old one. For much of that decade, when people asked me what I was writing, my response would be a kind of stammering incoherence as I attempted to describe how I was calling into the lovely thickets of art and everyday life—my own experiments with sympathetic echo. My efforts to find in life's discordant plunkings the musical vibration didn't feel quite anchored in the authority of form. Writing my way into and out of landscape, painting, literature, affection, sorrow, and even death, however, has been a happy experience of constant motion, motion that meant an overwhelming encounter with the southwestern landscape could lead to an intimate moment with a Vermeer portrait, for example, or a broken heart to laughter in a meadow. Now these twenty-one essays trace a progression of discoveries, by way of written language, about the natural world, art, grief and loss, and great pleasure—a process that has also changed the reality experienced.

This collection opens with a series of internal conversations around the problem of being true to one's own story: how narrative plays in and out of direct experience.

The second section picks up the theme of loss and mourning, trying out different ways of being with grief, letting different ways of writing it take its measure. This measuring, as it happens, carried me to an homage to Grace Paley, for whom the little disturbances of man were unendingly interesting, the unending object of friendliness. Grace Paley: without her intense and funny syntax I might never have written anything at all.

The third section takes up how wide and strange and interesting indeed is the world—in spite of time's bite, in spite of our losses. How curious and amusing is our presence in its many theaters: as visitors in and inhabitants of the natural world, as players in our own lives. In these essays are encounters with manatees and wild turkeys, snakes, children, and that most instructively civilized of creatures, Marcel Proust.

That hopeful interval leads into the final section, where the play

of narrative focuses on the freedom of art, and two different places where art interacts with our time-based lives: the spacious and rigorous art installations at the Chinati Foundation in Marfa, Texas, and that rapid, breathtaking display of formal innovation, the movies, with a selective history of pleasure in its particular artifice.

My task as a translator has been to be simultaneously inside and outside the forest of experience, to show how what's given harmonizes with what's made. From such doubleness these essays take their form and their content and their song. Motion itself is their ambition and their condition; they are moving in and out of art and nature, as art and nature move in and out of each other and as we move in and out of them, and in and out of time, calling hopefully into an impossible eternity, *somewhere.*

I.
Internal
Conversations

The Task of the Translator

Unlike a work of literature, translation does not find itself in the center of the language forest, but on the outside facing the wooded ridge; it calls into it without entering, aiming at that single spot where the echo is able to give, in its own language, the reverberation of the work in the alien one.

—Walter Benjamin, "The Task of the Translator"

SINCE THE FIRST TIME I saw it, the landscape of the southwest United States has seemed to me a place that unhinges ordinary response. First, heat and red earth and derelict gas pumps. Then citadels of rock and high adobe villages as old as Chartres—geological and human history, along with the occasional dinosaur track. I am now, as I was then, looking for a way to translate it—to enter its strange silent forest, to call into it from the wooded ridge of the future, as I was then from the isolation of an automobile. Benjamin says that translation expresses a hidden relationship, which is what I am looking for, but there's something a little sad about being on the outside of things, looking for the single spot from which to call.

That long ago morning I had been up early, eager to be off, to begin the great work of New Mexico. My co-translator had had a different idea. We quarreled. Wretched, angry, I left the little rented casita and walked across crumbly dry road down to the river—the Rio Grande, as it happened, but not in its grandest guise. No geo-political or scenic drama; just a fast flowing bit of brown water beside a mound of hard, parched earth, with mountains in the distance. An ordinary corner of the story: sun and hurrying water.

A little water animal swam suddenly, very fast, around a bit of island in the stream. Then again only the flowing water and the weeds and the light on the hills. Suddenly again it rushed out, grabbed a mouthful of grass and, holding it up to stay dry, was gone. Time passed. The sun grew warmer. A big fish moved slowly just under the surface of the brown river below my gaze. Everything relentlessly just being what it was, although at first I mistook the long dorsal fin for a snake.

Benjamin's essay on translation is quite the catalog of metaphors and images—of things being not exactly what they are. The relationship between original and translation is the undoing of a spell, the freeing of a spirit, he says, which is so much what I was hoping for as I reached for this landscape. Or, it is like the tangent, he says, which *touches a circle lightly and at but one point, with this* touch *rather than with the point setting the law according to which it is to continue on its straight path to infinity.* The touch point is like the spot on the wooded ridge that evokes the echo: very small in terms of meaning, but setting a course of its own arising from the freely shifting nature of language itself. The idea here is the light touch, and the translator free to go off on a tangent, to see infinity. I'd seen the little animal and the snaky fin and the sun falling on my own quiet skin as well, and the swift oblivious water. I thought of the quarrel, and of other quarrels and sad moments; plus it was now after ten. This was not exactly the light touch, this tangent; not the right echo.

Unlike me, these images of Benjamin's accept alienation, and lonely difference. Instead of brooding or disappointment, there's the relief of not getting lost in the thicket of language. And then, as it happens, there appears a relationship, calling and listening, the world answering back, otherness responding in a voice at once yours and its own. The light touch, not hacking away, is what gets the forest to yield its dark loveliness.

Only, how hard it can be to touch the right point. Take Bandolier National Monument, a series of caves where hundreds of years previ-

ously the Anasazi Indians lived in a vertical community carved into a cliff face. At the foot of it is an uninviting cafeteria and a couple of picnic tables beneath a hummingbird feeder, and little birds coming and going, remarkable, miraculous. Hungry, lonely, out of place and unable to eat, I wept until the suntan lotion stung my eyes. All the while, above and all around me a secret life hummed and whirred and died.

That night everything changed. A hailstorm, shocking and exciting and strange—polar white all over the dusty ground, as if the sky were falling. We went out to dinner, and afterwards strolled up a terraced hillside in the dark, where there appeared to be a straight path leading if not toward infinity, then perhaps to a view. A very small, very bright moon shone very far away. I stepped over the low barrier onto the path, and in slow-motion surprise realized I was calf-deep in water. Unacceptable, untranslatable knowledge: I kept stepping with my other foot and this time the stream toppled me and as I sat in a foot of cold flowing water, soaked to the waist, the tangent touched the circle.

In an instant the whole meaning of being here was to get dry. This unexpected water made everything crazy, and free. The spell was broken; the missing word for the translation was *laughter* and here was some real slapstick: the silent comedy of my dressed-up self. Dripping, soaking, uncontrollable wet. River and hailstorm and small bright moon and hummingbirds, and a jumble of dirty laundry in the trunk of the car from which I retrieved a dry nightgown to cover the point of touch.

How to go on from this moment of enlightenment? How to hold it, to stay with it? Where is Benjamin now? Busy with another metaphor. Content and language are like fruit and skin in the original, he says, while the translation *envelops its content like a royal robe with ample folds*. Here I am in this dirty nightie, and he hands me a peach, possibly wrapped in gold foil. Now it seems translation is not just about the light touch on the circle, but about an amplitude of relationship.

The task of the translator is to call and to touch and also to enfold. To overcome difference by taking it in, by being different. In the upside-down world of Arizona's Canyon de Chelly, I was a stranger. Trees and farms a thousand feet below the trailhead; more than a thousand years of Native American history: basketmakers, villagers, sheep, ruins. Switchbacks in the rock take you down to that hidden world under the hot sky, to ruined pueblos at the edge of a dark opening in the massive red stone, to cottonwood and Russian olive. On the sandy floor I sat in the shade, waiting quietly to understand how long it took for the river Chelly to open the rock and if by descending into this opening I had truly entered this new, old, world. What eyes did I need to see it, and what language could take shape to frame it?

A decade has gone by since I took up this task, and now the echoing world is everywhere. In New York City I remain attentive to the call of my own species into the vastness of time: the silent weight of geology, the infinite lightness of art. I go to the Vermeer show at the Metropolitan Museum of Art. Outside the air is crystal perfect, a morning in spring. The fountains throw jets of water into the newness of the day. I have arrived early and enter the exhibition from the back end, through the gift shop. At the other end the rooms are filling up quickly, but I have some time alone with *The Art of Painting*, and also with a large canvas by Leonaert Bramer called *Musicians on a Terrace*. I am willfully slow, as if there were time for all of it, as if very shortly I were not about to be in a great struggle for a place in front of the paintings, as if Vermeer could indeed unfold for me in the context of seventeenth-century Delft, as the curators wished, as if then and now were the same, no translation necessary. On Bramer's terrace there are eight musicians, casually set up as a tumble of pluckers and blowers and pipers and bowers. Instruments like pieces of fruit are falling out of the lower right corner. One of the musicians, turning toward the woman playing the violin, is sticking his bottom right in the view-

er's face. Bramer painted this over another painting, and bits of it can be seen vaguely emerging in the sky. A strange animal face peers from the darkness of the lower left, just off the terrace, under the surface painting.

Later in the morning I will see many paintings of church interiors, great open spaces with soaring columns and square-tiled floors where people stroll and chat and flirt. Around me in this space of art others are doing the same. We are all shifting and milling and peering and murmuring and sending out our hopeful tangents toward the paintings, calling into the forest of art, while there is still time, before the museum closes, before the show comes down, before we are succeeded by the generations to come.

Vermeer had daughters, many daughters. One of them is looking out of the darkness behind her in *Study of a Young Woman*, her face bare and a little unsettling. She's not the famous girl with the pearl earring, although she is wearing one and her head is turned just the same way. Her face is luminous the way Vermeer does that thing with light. The paint is covered with tiny cracks all over in a pattern that defies representation. On the surface, that is, time is showing like a veil over the timeless, mysterious youngness of her open eyes and quiet pale mouth. She could disappear into the darkness behind her, into the forest, but she hasn't. Right now she is in this room where I am standing on the edge between her world and mine. *A real translation*, says Benjamin, *is transparent*. We do not speak.

Silence; closeness. Art. Marcel Proust sends his character Bergotte, a famous writer, to see Vermeer's painting called *A View of Delft*. Bergotte thinks to himself that he should have written the way Vermeer painted, going over his books *with a few layers of colour;* he thinks he should have *made my language precious in itself, like this little patch of yellow wall*. And then, his mind occupied with that yellow, and also with the potatoes he had eaten before leaving the house, he falls out of life, turns into someone dead. The *skill and refinement* lavished on that little patch of yellow wall even though Vermeer had no obligation to take so much trouble with it is part of Proust's

argument about art: that it brings us closer to the laws of *a different world, a world based on kindness, scrupulousness, self-sacrifice, a world entirely different from this one and which we leave in order to be born on this earth.* He believes that Bergotte's books, Vermeer's paintings, bring us closer to that world and to the invisible laws whose precepts, he says, are traced on our hearts by an unknown hand. He is saying that art itself is a translation, a calling into loss, into the Anasazi caves, the hummingbird hearts, then pausing to listen for the echo, the whir, our other voice.

Bergotte's death scene is perhaps a familiar kind of translation, from experience into art: Proust's own last trip out of his apartment, which included an attack of dizziness that left him frightened and shaken, was to an exhibit of Dutch paintings that included the View of Delft. But Proust went beyond Bergotte; he gave himself to the lost language of the unknown hand, going over his books with a few layers of color, to the point even of translating into literary art the particular impression that a work of visual art can effect. Listen as he calls into the forest of art in order to show us how in an Impressionist painting (by the artist he calls Elstir) the divide between land and sea is made indistinct: you see churches, he says, *as if surrounded with water on every side because you saw them without seeing the town, in a powdery haze of sunlight and crumbling alabaster or in sea-foam. . . .*

The description goes on for two (very) full pages, describing and offering the experience of the process of looking. The crumbling waves, for example, describe both the paint itself and the blurred land-sea illusion. In this narrative of perception the reader is offered powdery sunlight and blown alabaster as a drama of painting itself unfolds: *fishermen riding bareback on the water as though on a swift and fiery animal whose rearing, but for their skill must have unseated them.* Proust's vocabulary and syntax rear like a swift and fiery animal, and all my skills are required to keep from being unseated. I keep going, to the boatmen, *blithe but none the less attentive, trimming the bellying sail, everyone keeping his place in order not to unbalance and capsize the boat. . . ,* and now Proust himself has entered the painting: *and so they went scudding through sun-*

lit fields and shady places, rushing down the slopes. It was a fine morning, he adds, *in spite of the recent storm.*

A fine morning indeed, because the visual harbor has taken on a fictional reality, the boatmen are alive and moving, a team on the run—even as what's in front of me is a solid and uninflected page of print. He has hit the spot where the echo reverberates; he enfolds the painting in his language, and disappears into the relationship. Watch carefully how he describes the sea in the painting, how he translates paint into a verbal dream, transforms seeing into a companionship of literary excitement. *One's reason*, he begins his conclusion to this tale of looking, *then set to work to make a single element of what was in one place black beneath a gathering storm, a little further all of one colour with the sky and brightly burnished, and elsewhere so bleached by sunshine, haze, and foam, so compact, so terrestrial, so circumscribed with houses that one thought of some white stone causeway or of a field of snow, up the slope of which one was alarmed to see a ship come climbing high and dry, as a carriage climbs dripping from a ford, but which a moment later, when you saw on the raised, uneven surface of the solid plain boats drunkenly heaving, you understood, identical in all these different aspects, to be still the sea.*

One's reason is staggering through the print, drunk, dripping, alarmed; bleached, compact, terrestrial, and circumscribed; in a word, panicked. Walter Benjamin calls Proust's sentences a *Nile of language,* overflowing, fructifying. Indeed, they cannot be encompassed. The eye travels over them in a kind of terror, scrambling across the raised surface of a phrase, to a heaving clause, climbing dripping from a parenthesis. No rummaging in the dirty laundry will save you here. You have to be with the language as you are with Vermeer's young daughter, or on the sandy canyon floor, quiet in the moment, on the page as the sentence unfolds, and unfolds again, until it fragments and comes together as a single element, and then releases you to the next one. Until you abandon yourself to standing on the ridge and listening for the echo from the forest, abandoned to the fine morning even though the next period is not in sight. When we are with art we

are calling from a loss of ourselves, and yet *one's reason* is also always part of the landscape. One's reason sets out to travel Proust's sentence from *element* to *sea*, and it is not a lonely trip because when Proust shakes out the royal robes of his language you are transformed into his partner. As he is the painter's. That's what I mean about closeness in art.

Metaphor is a translation of unsayable experience. Proust's voluminous enveloping of his own past, like Benjamin's essay, is a stream of metaphor and analogy, a seemingly infinite tangential exploration, an interminable afternoon at the edge of the forest. He seems to have all the time in the world to wait for the echo to call back from the depths of the wood, and finally so do you. Time to sit by a fast-moving river watching a slow fish ripple its dorsal fin, or to let the desert distances unfold through the window of a car. To come again and again to the paintings, and to share their silent closeness with whoever else is there that day. Metaphor is the echo from the wooded ridge, lost time reverberating in the alien moment at hand, the only moment there ever is.

Outside the beautiful world is rushing by, New York and Delft and New Mexico and Japan and the coast of France. I visit a friend in his studio at the edge of Soho. It is late afternoon. Western sunlight fills the enormous bare room, which seems brighter than outside. As bright as the harbor in that painting, or the flower fields of Arles, or Arizona rock in August. Only a few paintings on the walls, lots of open white brick. The paintings are made with gold leaf and dark calligraphic sweeps. The artist's shoes are covered in colorful paint drippings. He shows me a little wooden cabinet, smooth to the touch. One by one I pull out the drawers; in each I find the same face: a flat skull, a death's head carved in polished shell—abalone, mother-of-pearl, black or iridescent, very smooth and beautiful, works of *so much skill and refinement*, works of unexpected transparency; once more *a real translation* from a lost world of kindness, and care, and selflessness. On a low round table is a glass pitcher made so that handle and container are the same, both

holding the water. Separate from the world outside, in this quiet place with the light falling over everything, the moments unfold and the fragments come together, and I am one element in this perishable painting.

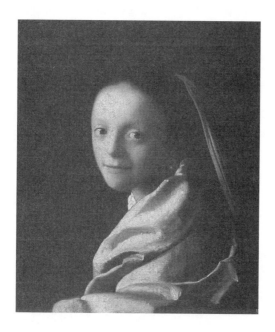

A Writer's Harvest

WHAT IF I WROTE A STORY and it had in it the word "jickjack-ing"—as in "jickjacking around," an activity I first encountered in a *New Yorker* story by Mary Karr. The jickjacking was part of her child-hood, which took place presumably in a world where actual jickjack-ing happened. That great American somewhere of fertile and colorful and vaguely illiterate but dead-on accurate phrasing. So she used the word with authority, even though now her name was appearing in a distinctly metropolitan publication. She still has those fertile roots—verbally, I mean.

The second jickjacking was in a very short story by David Foster Wallace that was written in the voice of someone I guess from the same roots, though not Wallace's—maybe just borrowed from Mary Karr—but still with its own kind of authority. You know how he could get you to feel: suddenly You Are There, and somebody is yes, talking to *you*. This was a boy's voice, an observant voice you drop into without any introduction: the first word is "Plus," only you've missed whatever the story is being added on to (as is almost always the case with a story, if you think about it). This story was about how much better people feel if they think they're getting a deal on something than if they're just hauling it off for free—just paying a few dollars.

If they got it for free then they'd have a relationship, is the idea. The old object (in this case a piece of farm machinery, a harrow, or a til- ler, which confused me at first because I thought of a tiller on a boat, and the language in this story was not taking place near one of the oceans that our amazing sea-to-shining-sea country commands, but instead in a more heartland, real-folks-out-in-the-middle-of-God's- country kind of place, and then I figured out that a tiller was some- thing you till the land with, which I still don't exactly know what that is, but at least I felt more honest about the way I was hurrying through the fifty- or hundred-word sentence) the old object, as I said, wouldn't be a link between the folks who didn't need it anymore and the folks who did. If money changes hands, there isn't going to be any more future jickjacking together about other topics. If they run into each other at the feed store, say, or some other heartland-God's- country kind of place, there wouldn't be the danger of inquiries about the old tiller, which could lead to further intimacies about more per- sonal kinds of abandoned junk, or eventually even to exchanges about missing teeth, like on the harrow or, if things got real loose, in one of their mouths.

I *know* a harrow has teeth. It's true that harrowing is mostly known to me in its metaphorical transformation—for example, a harrowing experience would be one that left its tooth marks on you, changed you in some way, possibly left you more fertile, a place with some new grooves. Anyway, that's how I see it. And I'm not as unfamiliar with the soil as you might think, having spent some time myself in places where tilling and harrowing and throwing bundles of hay onto a mov- ing wagon happen regularly. I may even have done some jickjacking, although probably not—I think it's the kind of thing you are born to and haul away for free.

But I'll be watching to see if it comes up again soon in *The New Yorker* or some more enigmatic and up-to-date purveyor of metaphor and diction and general verbal pleasure. For that and for any other bit of linguistic machinery somebody has been cleaning out of their barn

and wants hauled away without money changing hands. For I am one whose jickjacking heart does beat for language, and if you tell me a word in the morning I will try to use it by lunchtime.

Sebald in Starbucks

MARFA, TEXAS. DRY GRASSLANDS, desert and mountains. The western corner of Texas wedged between Mexico and New Mexico, where the hot emptiness of the Chihuahuan Desert obliterates the border, keeping the Border Patrol wired and alert. The railroad runs through it; the railroad put it on the map; the railroad is still hauling freight from the California coast to the Gulf of Mexico, almost 800 miles across Texas. The trains run through all day and all night, hooting, calling, sometimes a hundred cars long, moving across the high desert. At night the great eyes of the engine lights move east, move west, through the darkness. Under black skies, or moonlit ones.

Marfa is a funny sounding name. Like a child's lisp, or a foreigner who can't get that troublesome English *th* sound. Or like a brand name cobbled together out of two people's names— Marfa Delivery, maybe, or Marfa Soap, recalling Marv and Fanny, or Martinez and Farrell. As it happens, this little whistle stop, founded to accommodate the railroad in 1881, was named by a Russian, a woman, a frontier wife brought to the wide views of the Chihuahuan Desert and the long view of the iron rails cutting through it because her husband was a railroad overseer. So, one important thing to know is that in Russian

that Cyrillic *f*-sound is perfectly acceptable. A literate woman, read-
ing *The Brothers Karamazov* by Fyodor Dostoevsky, provided a name
for the place from her reading, from the Karamazov family servant,
whom nobody remembers, but to whom Dostoevsky gave the name
Marfa. And if you think about it, Fyodor has the same problem of the
lispy-sounding *f* instead of *th*.

What seizes the imagination here is the woman reading a recently
published novel, something just out from a contemporary writer from
home. She was on the other side of the world from Fyodor and his
Karamazovs, the dysfunctional relationships, unholy and holy desires,
the exploding sentences. Possibly for her it was a link to home, pos-
sibly it was a way to while away the long hot days in the desert, a
way to defeat the interminable space and the bright eye and lonely
hooting of the trains. Did she know that she was reading Russian
Literature? (Dostoevsky: Isaiah Berlin's great example of the literary
hedgehog, the thinker who knows One Big Thing; outsider, epileptic,
prophet; in 1881, just dead in St. Petersburg.) She was reading a novel
published the previous year and brought along to Texas, where she,
nameless footnote to America's Manifest Destiny, dropped the simple
and rather foolish name of one of its minor characters.

In Marfa for a quiet month of work, I began reading *Austerlitz*
by W. G. Sebald. I have read other books by this same author, and
of course many other books by authors both dead and alive. So many
authors are alive in my time with their names before the public but
some of them you can read very quickly. Now I am reading Sebald's
book, also a recently published work of fiction, in a Starbuck's in
Massachusetts, and I find I am reading very slowly, almost word by
word, following its winding sentences and paragraphs, and looking at
its strange photographs (all Sebald's books scatter photographs, black
and white snapshots without captions, that illustrate not so much
the story he is telling as the difference between his precise text and
the camera's casual glance), and sometimes going back and rereading
pages or looking at how many pages are necessary for one paragraph
(twenty-five is not unusual).

I would say the effect is dreamlike, entrancing, except that the associativeness, the quiet shifts and turnings are also keeping me alert—to time and place and simultaneity. This author now is pulling me through cities and vistas and time, down through layers of narrators (but always reminding me, in the gentlest, most rhythmical way, who is speaking) into his story and around it and behind it. I am moving into the past with him, but like the railway overseer's wife I am also moving into the future, because with this book in my hands I am connected to those who will read this book in the future and know this author's name as part of Literature. My immersion in the mental world of *Austerlitz*, my meaningful now, does not undo the strangeness of this object, bought in a bookstore in Ohio and carried to Texas and then to Massachusetts, where I am now reading it just as I read the other books I have on my desk or by my bed or waiting for me elsewhere in my restless life. Only unlike most of those, I am pretty sure, this book in my mortal hands has the uncanniness of its life in a future when I am long dead.

Sebald himself has recently died, like Dostoevsky back then, though a few years younger. By doing so he has turned himself into an untimely loss, an example of the senselessness of things. Sebald writes without drama of horror and loss, of the sudden incursion of unreality into the real world, of the possible co-existence of all moments of time in the same space. Loss of family, of country, of mind share in his sentences unsensational space with sunlight coming through the feathers of a bird's wings, or a perfectly appointed billiards room left shuttered and untouched for a hundred and fifty years.

In this quiet way, on an unperturbed Monday morning, he is describing for me a Nazi prison in Belgium called Breendonck, and a particularly horrible Nazi torture. I am sitting in Starbucks and the woman at the next table has a drink topped with a mound of whipped cream under a plastic bubble. And music is quietly bubbling around the readers and writers and talkers at the other little tables. Everything is easy and safe: the friendly guys at the counter, the sweet and pungent coffee smell, the busy brains of Cambridge in here and

walking by outside. Across the street the little green box of the ATM kiosk, a corner in a familiar world, unruffled sunlight of late winter.

Into all this Sebald, known as Max to his friends when he was alive and writing the words I am reading, brings that other world so gently, in one long sentence, a sentence like a distant line of freight cars across the high grasslands, with the irony only of its unexpected appearance in a passage about a seemingly random memory of the laundry room in the narrator's childhood home, an image connected to the Holocaust only by the fact of its invoking a German word his father liked and he didn't—*Wurzelbürste*, the word for scrubbing brush—but slipping on the soft soap smell of its umlaut into a story of a prisoner at Dachau who, upon his release, left for the jungles of South America, a self-exile that leads the section of the book I am holding to end with three lines of capital A's, *like a long drawn out scream*, says Sebald.

So it becomes afternoon in Cambridge, the sun slipping farther across the street. The outsized Flemish fortress of Breendonck proved a useless defense in the First World War, and again in the second one. Its history and the cruelty practiced therein are an hour further away, as Sebald tells it first in English, and then repeating the original French of another writer's memories, and then giving more details about the Frenchman's intention to put distance between horror and himself (a green jungle, a painting that repeats and repeats the letter A) so this telling over in unwinding sentences of a past is now part of the daily peace of my small city on a Monday. A city full of my own past and my own busy and mysterious brain, so many Mondays thinking and beginning again and drifting in long winding sentences to maybe just the repetition of the capital letter A.

I think his endless unruffled paragraphs show how reading works, how the mind moves from observing swallows in Wales to a cleverly contrived suicide in Halifax to the Royal Observatory in Greenwich, the Border Patrol of time, where they calibrate with instruments as beautiful and mysterious as his sentences. It is my good fortune right now to be reading this and going into it and being part of it, an

early reader, a contemporary reader, a person in its world—as the woman who named Marfa was in the servant Marfa's, and also in Dostoevsky's. That world of calibrated and timeless language does not seem to be part of this transient sublunary Starbucks at all, but mine are the nameless hands and eyes and brain it is passing through while all the moments of our lives, Sebald says, are occupying the same space. Time is going through me and all around me and I am sitting in a chair with a book in my hands. Entirely lost but still there, like the wife of the railway overseer, like the Russians in Texas, like the tumbleweed along the tracks and the long hooting of the train in the dark Texas night.

Eye Shadows

Things are different in Japan, as you can see from looking at their paintings. There it's flatter and quieter than here; what's in the foreground and the background has a different perspective, not this coming to a point at the back of the image—at first such an important innovation but later exposed as phallocentric and cutting off other gazing possibilities. It's very curious about successful innovations, at first they seem so wonderful—fantastic tools that let you do what's never been done before, like paint a colonnade whose columns recede into the back of the picture plane, or delete typographical errors with a keystroke, or get an out of print book from a shop in Florida you'll never visit, a virtual Florida, a Florida in your mind, a white beach with a bookshop where on the front table is the very book you need, the exact friend whose conversation will turn on the lights in your head.

Then these remarkable things turn you their dark side. I don't mean just selling used make-up on e-Bay, which is a harmless enough teenage activity, although of course it might be better for the buyer and seller to be in one of their bedrooms actually enjoying each other's company while experimenting with colorful additions to the faces God gave them to carry forth into the worlds of love and power,

instead of just passing on the solitary disappointment of that ugly Topaz lipstick or the earth-toned eye shadow that created something out of a medical textbook instead of a smoky lake of desire. I don't even mean fruitless and buzzed up hours of crawling the web for lower fares or a place where the weather is better.

No, the dark side would be something like the way perspective takes over the eye, not like a disease, but precisely like desire, so that visual pleasure gets measured in three dimensions for so long that it takes a really aggressive act to get our eyes open again, like Commodore Perry banging his boats into the Japanese ports or a talented little Spanish egotist painting a woman with both eyes on the same side of her face.

Not that there isn't plenty to be said for women who don't look like flounder, and for artists like Vermeer. I love the way he does those tiled floors, the way he makes you gaze as he does, and so enter his world of three-dimensional pleasure, his particular art of painting: the laurel crown both on the model and also the first thing that has taken shape on the canvas—laurels for the painter's working hand. And you can't accuse Vermeer of a mindless dependence on perspective. Check out the map on the back wall: all the Netherlands provinces abstracted, flat. Or if it's not a map, it's an earlier painting... and that's as far as you can go into his painted space. Even though it seems obvious that you're looking at a real place right now, a studio or a music room or a table where two people are sharing a beer, part of that reality turns out to be a two-dimensional record of the past: the outlines of a vanished Holland or a canvas in a frame. His empires of art and power are shadowed, like his subtly lit studio, by elsewhere, by the possibility of time and change. And you can never know what will come out of shadows. You can't see if representation will turn into a lie, if love will arrive like the dimmed or dazzled pain of an eye disease, or unveil its smoky lakes of desire.

Centuries elapse, empire keeps moving; Vincent Van Gogh falls in love with the art of Japan, with the incorrectnesses, the alterations of reality—truer than literal truth, he wrote to his brother. He

takes you into his bedroom to share his experiment in Arles, in-your-face color: the blue walls, his own tacked-up paintings as real as the thickly painted bed, and skillful imitation tossed out the green, half-open window. He painted a bridge in the rain, copying from a wood-cut by Hiroshige the diagonal composition, the hurrying figures, the smoky sky over the water. Then, like Vermeer showcasing his unmistakable skill, he puts his two-dimensional, borrowed world into a frame of his own devising. His virtual Japan has a green border with red Japanese characters. This is how he mentions time's perspective on paint and place.

And the phallocentrism problem? Has the virtual friendship, this cross-cultural virtuosity at last slipped the traps of gender? Those Japanese characters on the green border, that witty and loving reference to the Japanese eye. . . . Oh, they were copied from signs he couldn't read, some of them as it happens, well, advertising brothels.

Monkey Mind

A NARRATIVE IS SUPPOSED TO HAVE an arc, but when I'm getting from one place to another digression is how the story leaves the gate. If I am told about a giant tortoise in connection with an explorer in the Florida swamps in the eighteenth century, I will remember a tortoise I saw in a play long ago in London, a tortoise whose silent presence is part of the play's knitting or folding gestures with time, and now retraces its pattern into my own unwinding skein of things.

Digression will lead both off the track and somewhere very interesting, depending on your tolerance for lyric or syntactical uncertainty. This is true for others as well, Proust of course, just to mention the most monumental example, or Leopold Bloom digressing all over the city of Dublin while Joyce in Trieste is working for Berlitz and speaking to his family in Italian. I heard an artist yesterday mention a disk jockey called Singe, and then associating to a painting of his own that plays on the name, *singe like burn*, he said, *or monkey*, rapidly moving on to reference trickster figures in a breathless footnote. Well, you'd have to know French to get the pun, but the artist kept going without further explanation. He spoke urgently, borrowing the cadences of African-American speech, although only when he was on his feet.

Disruption, collage, postmodernism, concrete fiction—visual art-
ists whiz all over the place with their material objects, and immaterial
ones as well: sound installations, videos, web-streaming, splotches of
idea. I suppose you could say poets also do this, letting language lead
them, the happiness of meter and rhyme, the precision of image and
sound, and thought riding the waves, leaping the intervals and caesu-
ras. Not like the essay, which is supposed to have a thread that leads
through the maze, constant reassurance that the hybrid monster can
be outrun.

Still, what exactly is the problem with verbal digression? A side
trip that leads to nothing more than a view of farmland and the late
afternoon sunlight turning the corn plants gold or transparent? Or an
interior courtyard where a woman is braiding a child's hair? A steep
city street and a snatch of song that makes you feel you're in a movie?
The problem with digression is that it seems to frustrate logic, to keep
offering an unfolding world, which is all very well, but unfolding—at
least from moment to moment—is unsteadying, queasy-making. The
eye leaps ahead looking for the shore. How does the corn leaf con-
nect to the bricks in the courtyard and the melody on the soundtrack?
Where, as Henry James asked when he read George Eliot's compli-
cated *Middlemarch*, is the plan?

You can't just appeal to chaos theory, the butterfly wing busi-
ness, the ironies of remote causality. I'm thinking now that digression
raises a problem of trust because it asks you simply to assume a friend
is rowing beside you, pointing out the special qualities of light, play-
ing the scene with you—it requires companionship. If you're wan-
dering all over Dublin humping from graveyard to brothel to kitchen
drawer, you want to be sure you're with someone you like.

W. G. Sebald takes you wandering all over East Anglia, far into
the past and the library, over ruins and heaths. He invites slowness
and rereading, pausing and marginalia. He tangles you into his sen-
tences and paragraphs. Reading them is an experience of being pulled
forward always, the next sentence and the next a promising, unmissa-
ble, unstoppable beckoning, like a walk that you can't turn back from

because the next turning or shaded run is too much a part of where you are going in your own life. Just so does he begin with an iron bridge over the river Blyth, a bridge built to accommodate a miniature train, a little curiosity once devised for a Chinese emperor and inexplicably ending its days on a local English rail line, and then he unfolds from the mythical dragon that once decorated its carriages an endlessly woven silken fabric: the Taipei rebellion, and a history of British colonial barbarity and diplomatic prevarication, as he says; the breathtaking aesthetic destruction of the earthly paradise of the Yuan Ming Yuan gardens near Peking, and so on to the extravagant and extravagantly powerful Dowager Empress to whom the deaths of millions resembled flies caught in a jam jar, to whom the ideal subjects were her silkworms, diligent in service, ready to die, capable of multiplying vastly within a short space of time, and fixed on their one sole preordained aim, wholly unlike human beings, he suggests, on whom there was basically no relying. Her death, he says, toward the end of a paragraph seven pages long, occurred a few hours after she had defied her doctors' warnings by consuming a double helping of crab apples and clotted cream, her favorite dessert.

Again and again he offers a quiet reverberating irony, his own language following the grotesque details, the imaginative paradoxes of the natural and human worlds, of inevitable loss and unavoidable connection. He offers a shuffle of little photographs too, but all of his story matters because his thousands of words are always turning toward new views. He chooses to call his virtuoso literary pivoting fiction, even though it has real people in it, and real places, and real historical events, all of them clearly described by name.

This useful sleight of hand has been going on for a long time. Eliot's *Middlemarch* takes a very young and idealistic woman and shows how youth and ideals can lead to the deathliest of lives, later letting the plot digress, allowing her Dorothea to sidestep death and marry love and art. Which is what she did herself, of course. In the formal guise of fiction she digresses into glorious metaphor that illuminates the cornfields and courtyards of human endeavor as she has

lived in them. Her essays, on the other hand, are distinguished by plan and backbone and sharp intelligence. They are full of pleasure and information, but they do not follow a private trail to a surprising moment on the river.

George Eliot (even her name is a fiction—she was Mary Ann Evans, digressing to Marian Lewes and finally Mrs. John Cross) died in 1880. You would think by this time digression would be better understood. You would think that analysis and observation lying quietly in a long self-delighting sentence would not go unnoticed, a pleasure of recurring phrases turned to different tasks and waving from the side of the road, or running along beside you in the underbrush. Why, Eliot asks, should a story not be told in the most irregular fashion that an author's idiosyncrasy may prompt? History, says Sebald, staggers blindly from one disaster to the next and inscribing onto one's own body of memories its noisy and spectacular highlights, he suggests, is a form of entombment. There is no plan; one goes on in its horrible ridiculous absence. The dear public, notes Eliot, would do well to reflect that they are often bored from the want of flexibility in their own minds. I digressed, says Grace Paley in the middle of a painful conversation, and was free.

Only put yourself, then, into the care of another voice and let wandering in its language surprise you until the seeming weightlessness of the logic is recognized as the air you are breathing and you realize that your lungs and your head are in direct communication, and that your backbone is still relaxed—time and friendship having done the job; the threads of language knit up, the song resolved, the dragon a terrible silken beauty, and the monkey laughing in the tangled trees because once again the tortoise has won the race.

Henry Adams in Japan

A Bad Night

HENRY ADAMS DID NOT SEE THE POINT of Japan. It seemed to him infinitely childish—*the whole show is of the nursery*, he said, and *nothing is serious*. It was very hot in the summer of 1886, when he spent three months there with the painter John La Farge. *Japan is the place to perspire*, he wrote to his closest friend John Hay. The food was awful, the smells worse. Even the tea was dreadful, although the tea ceremony itself he suggested was *the only serious labor of Japanese life*. This observation notwithstanding, he bypassed the opportunity to acquire *a book which contained paintings showing fifty arrangements of the charcoal to boil the kettle on this occasion; and as many more of the ways in which a single flower might be set in a porcelain stand.* The whisper of sarcasm indicating the Japanese concentration on aesthetics was in fact absurd.

La Farge, on the other hand, found the Japanese sensitivity to the world's beauties "much more delicate and complex and contemplative, and at the same time more natural, than ours has ever been." In the heat shimmering over the flooded rice fields, La Farge saw a crane "spread a shining wing and [sink] again"; he saw the pink lotus flowers standing up in the ditches. An early letter conveys

dispassionately the information that manuring the fields taints the drinking water, shortening life. Only when they arrive at their overnight accommodations on the journey from Tokyo to Nikko does he get a touch more personal: "inexpressibly outrageous" is the odor on the entry floor; "evidently of the same nature as that of the rice fields," he adds, informatively.

Every house is a cess-pool, was Adams's version. *The surrounding country is one vast, submerged rice-field, saturated with the human excrement of many generations of Japanese.* The vigorous disgust cuts through earlier ironic responses to the country, e.g., reporting himself pleased to be relieved of the fear that he'd lost his sense of smell by the *oily, sickish, slightly fetid odor* they found pervasive in Japan.

The upper rooms at their wayside inn, however, seemed clean and airy, although the furnishings rather bare by western standards. Even so, the night proved hideous. After a meal they concocted of canned Mulligatawny soup and boiled rice, Adams suffered an intestinal attack. He calls it cholera (an outbreak of which they were fleeing from Tokyo to the mountains), which does give an idea of what it felt like. In the morning he learned that La Farge had had a similar night. *We have never found out what upset us* (it was not, of course, cholera), he says, but he also notes that in their common suffering he was *reduced to laughing at La Farge's comments to a point where exhaustion became humorous.* La Farge turned their wretchedness into laughter.

Short Genes

In a later century a gene called 5-HTT has been discovered, a gene that comes long and short. If you have two long 5-HTT genes you are likely to have emotional resilience—elasticity of mind—and stress won't shrink or disorganize the structures in your brain. Lab mice with short genes, however, suffer neurochemically from stress. New Zealanders with two long genes, studied by geneticists from London, stay cheerful despite losses—of money, health, even loved ones. Such mental elasticity Jane Austen has described as the choic-

est gift of heaven. Henry Adams, despite his uncommon flexibility of thought, did not himself seem to be thus gifted, but possibly La Farge was. Adams found his friend's equanimity—an *attitude toward the universe* that did not vary whether seasick in a whaleboat or taking tea in Japan—perplexing and refreshing. Even before they crossed the Pacific, on the train trip from Albany to San Francisco, Adams tells Hay, *La Farge's delight with the landscape was the pleasantest thing in the journey*. (La Farge in fact had many reasons for delight in the journey; he was avoiding creditors, legal action, and an estranged wife and children.) *His* letters at any rate run long and delighted, and their travel details take note of pink lotus and giant cryptomeria as well as excremental rice fields and muddy roads. He enjoys drifting through the days when that is all the climate allows, "though A____ is not so well pleased. . . ." *His* bad night at the inn is simply a matter of "weary noise," nightmares, and a dawn "made hideous by the unbarring and rolling of the heavy *amados*, the clattering of clogs over pavement. . . ."

Adams's account brings that weary noise into linguistic flower. His description of the night is an exercise in the witty xenophobia often characteristic of American missions abroad. *At midnight I wooed slumber*, he begins, *but first the* amidos *or sliding shutters of the whole house below had to be slammed, for twenty minutes; then all the slammers had to take a last bath, with usual splashing and unutterable noises with their mouth and throat, which Bigelow assures us to be the only way of brushing their teeth*. He did finally sleep, but was wakened by the noise of *a man moving about and stopping every few steps to rap two bits of wood together—clack-clack— like castanets. He interested me for twenty minutes*, Adams writes, meaning by *interested* something deeply different. (He later learned that this was the watchman, notifying *thieves to be on their guard*.) It was *during this part of the entertainment*, he explains, that he was stricken with the digestive upheaval, after which (Adams now back in bed and longing for sleep) *the* amidos *began to slam again, the bath began to splash, the bathers choked and coughed, and chaos came*. Every word is placed so as to stretch those short stressed genes into a happiness of language that

defies what it means. The *entertainment* is what he is providing here for his correspondent. *Laugh . . . when you're in trouble*, the dying William Dudley in Adams's novel *Esther* tells his daughter: *Say something droll! then you're safe. I saw the whole regiment laugh under fire at Gettysburg.*

Crossing the Pacific

As for the reassuring Bigelow, that is William Sturgis Bigelow, scion of another Boston family and a cousin-in-law to Adams. By this time he had been in Japan for five years, avoiding the medical career and Brahmin marriage desired for him by his father, studying Buddhism, and buying up Japanese art. (He also bought that book about arranging the charcoal for the tea ceremony.) By the 1880s Japan had become a fashionable destination for wealthy travelers, despite the rigors of the Pacific crossing. After more than two centuries it had been opened to Western trade, and as Americans grew rich on their own industrializing enterprise, as they filled their houses with the art of the European past, they also began to reach for the exoticism of Japan. Lacquerware, fans, kimonos, screens, and piled up ladies' hairstyles came into vogue; beyond these lay its religious traditions, the Buddhist and Shinto philosophies expressed in daily life and artistic practice. That, too, came into vogue, especially in Boston, where there was a growing strain of spiritual seeking, an interest in the occult and the development of something beyond the materialism of American life. Among the rubble of conquest there is always new aesthetic pleasure. In the case of Japan there was also the possibility of religious adventure.

Adams was not sympathetic to this Oriental traveler's chic. The dynamic materialism of Western life became the intellectual challenge he found most relevant. The education of men of his generation, he says in *The Education of Henry Adams,* was to get rid of the stamp of Puritan politics and *take the stamp that belonged to their time.* His family lineage made him autobiographer of his own country's spirit; he became a historian of the forward-moving Western mind.

The long aesthetic and spiritual life preserved into the nineteenth century by Japan's isolation from the West made it seem unrelated to his concerns, despite the immense post-Shogun Japanese interest in Western education, government, and industrial advances. Where La Farge found a charming simplicity and sensitivity to natural beauty, Adams found archaism and childishness. He found in Bigelow's embrace of Buddhist practice little more than the common longing for *Paradise;* to seek it *in absorption in the Infinite* seemed to him even more of an illusion than that of finding it in love—at the *Fireside*, as he called it—which at least keeps one in the stream of ordinary life.

Bigelow eventually returned to Boston, donated his enormous Asian art collection to the Museum of Fine Arts, and took the spots on various Boards of Directors bequeathed to him by his father. (He did not, however, marry or practice medicine.) His personal correspondence is stylish and interesting, but it was never imagined in the hands of a public future. La Farge's letters, which *were* written for publication, always refer to Bigelow as the Doctor and Adams as A____, lest his friends' privacy be violated. The Doctor is an experienced guide, A____ a brilliant companion. Similar discretion elsewhere in Boston has led to the destruction of much interesting personal data, leaving the curious and imaginative future to contemplation, speculation, interpretation. A____: *The pen works for itself, and acts like a hand, modelling the plastic material over and over again to the form that suits it best.* The epistolary traveler and the historian both are sculptors.

Disappointment

Adams's letters are neither discreet nor indiscreet; in general their open indulgence in complaint about the weather, the aesthetics, the food, the boredom, even the horses (*all Japanese horses known to me are rats; and resemble their pictures, which I had supposed to be a bad drawing*) has the effect of drawing his reader close to him. For all their casual disparagement and distanced superiority, they keep the freshness of

their feeling. What traveler has not had a dreadful night of digestive rebellion accompanied by the local intolerable noises? To travel is to be at the mercy of one's body and one's prejudices, to live closely with the disgust of the unfamiliar. The beauties emerge in less profusion than the discomforts and absurdities, and all the world's a zoo.

The reiterated candor of Adams's sense that *Japs are monkeys, and the women very badly made monkeys*, however, seems irritable, or worse. Japanese women are an apparently unforgivable disappointment. *They are obviously wooden dolls*, he reports to John Hay, *badly made, and can only cackle, clatter in pattens over asphalt pavements in railway stations, and hop or slide in heelless straw sandals across floors*. To his Washington friend Elizabeth Cameron (herself very well made) he writes: *The Japanese women seem to me impossible. After careful inquiry I can hear of no specimen of your sex, in any class of society, whom I ought to look upon as other than a* curio. *They are all badly made, awkward in movement, and suggestive of monkeys*. Dolls, monkeys, curios—there simply is no sex in Japan *except as a scientific classification*, he tells Hay, and that principle, he concludes, is *the foundation of archaic society....Sex begins with the Aryan race*. The one Japanese beauty he meets, the wife of a high-born pottery-owner, he compares to *a bit of bric-a-brac*—probably a better bit than any other in her husband's potteries, *but as for being a woman, she is hardly the best Satsuma*.

This kind of imperialist bric-a-brac is not the hallmark of La Farge's letters, either in his descriptions of his own experience, or in his versions of his companion's conversation. "A_____'s historic sense," he says admiringly, "amounts to poetry, and his deductions and remarks always set my mind sailing into new channels." A_____ himself, though, was not so enthusiastic a sailor, ultimately questioning the very possibility of cause and effect in the stories historians tell. Moreover, by the end of the century he was seeing even scientific classification as an almost arbitrary modeling of plastic material into suitable form. The relation between steam and electrical current he thought as mysterious and inexplicable as that between the Cross and the cathedral.

Sailing into New Channels

As the summer passed in the cool of the mountains, lakes, and forests near Nikko, with the conveniences provided by Americans familiar with the place, Adams's spirit engaged his surroundings. In spite of himself he was impressed by Nikko: twenty landscaped acres of temples, tombs, ornament, and trees. It all made Versailles look rather a feeble show. La Farge describes Nikko as having "more details of beauty than all our architects now living, all together, could dream of accomplishing in the longest life.... This wood and plaster [has] more of the dignity of art and of its accessible beauty than all that we have at home, if melted together, would result in. . . ." Here La Farge himself is melting down, his enthusiasm running to national self-abasement. Adams never abandons his skepticism: *If I could satisfy myself that one perfect line or conception existed in Japanese architecture I should be quite satisfied; but my conscience protests while my eyes admire; and the aggressive bad taste of a part, hurts the triumph of the whole*, he tells John White Field. *I can find little to photograph, he adds, that wholly satisfies one's hunger for something neither gorgeous nor grotesque.* Sex, architecture, horses— he is not in the mood to absorb new impressions. In fourteen hours at Yamanaka's, the major export art dealer in Yokohama, he found *nothing good . . . not a kakimono* [scroll painting] *did we find, though we were shown them till we fairly kakimoaned.*

In fact, he spent many thousands of dollars and sent home crates of bric-a-brac, most of it for non-traveling friends. He also kept an extensive album of photographs, both his own and purchased. Much later he wrote, *For some things ignorance is good, and art is one of them.* In *The Education* he describes himself at twenty-eight, in London, running down the possibility that a drawing he's acquired for twelve shillings might be by Raphael. The question remained unanswered; he counted the twelve shillings a minor expense of the worldly education he was then eagerly pursuing. In Japan two decades later, shopping and making photographs, his judgments about painting, bronzes, and Satsuma pottery are restless and almost offhand. He

buys what is recommended by his more experienced friends, *none of it necessary to my existence.*

This journey to the east, as it happens, fell into the twenty-year period when he declared his "education" broken off in favor of *{standing} the chances of the world.* The world had previously sent him to Beverly Farms, Massachusetts, where he found the exact right wife, and then up the Nile on his honeymoon, where he took a terrific photograph at Abu Simbel; it sent them together to Washington, D.C, where he took up his career as American historian and (as *The Education* has it) *stable-companion to statesmen, whether they liked it or not.* In 1886 he found himself without her, in Japan: nose offended, eyes and conscience at war, irony unleashed. *I have laughed without stop, ever since landing,* he maintains. Even a thunderstorm convulses him, *sounding so like poor gongs that I could not believe it natural.*

Traveling Tips

A more circumspect perspective on the Japanese experience can be found in the guidebook Adams had with him on the trip, published by John Murray in 1884. *Handbook for Travellers in Central and Northern Japan* is a chunky, closely printed little tome with extensive information on flora and fauna, geography and religion, history and art. Its language is less ironic than Adams's but it outlines for nineteenth-century adventurers into the newly opened Orient a prospect of privation and discomfort as intimate as his. In the Introduction, under Luggage, Murray's authors show the tenderest care for their travelers and their necessary equipment, and suggest reducing the volume of stuff by sending provisions and clothing ahead, to be picked up along the way. The list under Dress begins with "Light flannel coat, made to hook up, and with pockets to button, so that when you take off your coat and give it to some one to carry, the contents are not in danger of falling out."

As for footgear, they recommend the Japanese straw sandals called *waraji*: "They should be made to order, according to the size

of the wearer's foot, and a supply of at least a dozen should be taken, as *waraji* large enough for an ordinary sized foot are not easily to be bought ready made. In dry weather a single pair will last for two days, and half that time in rain or mud." (La Farge mentions that on the wet road to Nikko even the horses were straw-shod.)

Concern for the big-footed traveler's personal comfort increases as the advice accumulates. Under Provisions the writers are firm: "It should be clearly understood that it is practically impossible, when travelling in most parts of the interior, to obtain anything in the way of foreign food, and those who cannot eat the native fare should therefore take with them their own supplies." There follows detailed advice on how (if your servant can make bread) to improvise an oven in a large rice pot, by placing it on its side, embedded in earth, and regulating the temperature using the lid. As for portable stores for use in points where the food is "of the poorest description" as well as scarce, they recommend Leibig's Extract of Beef, German Pea-soup Sausage, Chicago Corned Beef, Tinned Milk, Biscuits, Jam, Cheese, Salt and Mustard, Worcestershire Sauce, Bacon, Tea and Sugar. The tea at Japanese inns, they warn, sounding a rare note of frank disgust, "is of inferior quality, and often very little better than sun-dried refuse leaves." The traveler has been warned, and Adams indeed was very glad of the tea he brought with him from America, even though the Mulligatawny soup turned out to be no protection.

The hardships to be overcome if you want to see Japan are presented in Murray with both clarity and a dignified confidence in the reader's interpretive skills and elasticity of mind. In the Useful Hints section, however, the *Handbook* approaches an understanding that there are dark moments when there's no one there to hold your coat or bake your bread. "Keating's Insect Powder is indispensable," begins a paragraph omitted from the section on inns. The mats and quilts of the bedding "invariably swarm with fleas, and unless some preventive is used, the traveler will probably pass sleepless nights. The best method is to freely sprinkle the inside of the nightdress with the powder; where fleas are particularly annoying, its direct application to the person will

be found very effective." As in Adams's letters, careful details draw the reader close, modeling the plastic material to the form that suits it best: "A sheet of oiled-paper spread over the quilts before putting on the sheets is some protection, but its unpleasant smell has often the effect of causing a headache." The style lacks Adams's entertaining irony, but it is compelling in its own way.

Extreme Remarks

Adams is not a chronicler of the sublime but he does admit the natural scene to be *one of the sights of the world*. If he disparaged Japanese culture as no more than *a clear imitation of life*, the nature he found a kind of perfection. (It's another mark against the Japanese that they care more for their *filthy rice-fields* than for their lovely, empty mountains.) Possibly it's only calisthenics for his short genes rather than cultural intolerance that in the intimacy of his letters he found the *exquisite little lake with woody mountains reflected on its waters* less amusing to develop than the *wooden hut, open to all the winds*, where naked men, women, and children are bathing in complete immodesty. For ten minutes, it seems, the Americans *stood at the entrance of the largest bath-house, and looked at a dozen people of all ages, sexes and varieties of ugliness, who paid not the smallest regard to our presence*. Was the disgust less at the nakedness than at the way Aryan prurience is frustrated by the clear insensibility to it? (The only actual figure Adams places in this landscape of bathing is a pretty teenager who bothers to turn her back while drying herself.) Later, in *The Education,* his hegemonic claims for Aryan sex will dissipate: he compares sex itself, a multicultural, and female, power—the Virgin and Venus—to the dynamo. *In any previous age*, he says, *sex was strength*, the Virgin *as potent as X-rays*, and the goddesses of Greece and the Orient, as if animated dynamos, worshipped for their force. Perhaps not the clearest image, but not off-putting; a mystery perhaps like the beauty of a Satsuma bowl.

Adams biographer Edward Chalfant devotes roughly five pages to this summer of 1886, and mostly the complaints don't make it

into his account. His Adams praises Nikko's great shogun temples: *a mountain flank with its evergreens a hundred feet high modelled into a royal posthumous residence and deified abode.* He does not comment on Adams's grudging admiration of accomplishment: beyond *what I should have thought possible for Japs,* or on the neat summary that ends his description of Nikko: *It is a sort of Egypt in lacquer and greenth.* As with the pottery-owner's wife, the comparison simultaneously flatters and belittles. Possibly taking Adams's own advice to cut *whatever seems to delay the* story, *for a biography ought to be a story,* Chalfant doesn't pause to comment on the language. His Adams, though restless, is productive and elastic. He brings his travelers quickly to Mount Fuji two months later, where he offers La Farge's report that Adams said *it was worth coming to far Japan for this single day.*

Another biographer, Patricia O'Toole, points out that "Adams himself did not bother to note this enthusiasm." Such experience of utter fulfillment may be recompense for a traveler's Mulligatawny nights, but O'Toole, who devotes somewhat more attention than Chalfant to the Japanese passage in Adams's non-*Education* years, is more struck by the recoil his letters express. "Adams was eager to sum up the experience and move on," is her own summation.

A study of the work La Farge did in Japan, by James L. Yarnall, while crediting Adams's enormous generosity toward the artist, characterizes his attitude as "cynicism and bad humor." "He even took a swipe at the waterfall in the charming garden behind their house," Yarnall says, contrasting this with La Farge's particular pleasure in the way art and nature were blended in the pretty water feature. In biography, as in art and travel, it is hard to have an objective eye.

Eccentricity

Adams was forty-eight years old when he removed La Farge from his professional and domestic difficulties for the trip to Japan. Six months earlier his wife Clover, his own particular Fireside, who had shared his pleasure in irony and horseback riding and the drama of

national politics, whose *excentricity* suited him down to the ground, had committed suicide. *When you know my young woman*, he wrote to his English friend Charles Milnes Gaskell in 1872, just before their marriage, *you will understand why the world thinks we must be allowed to do what we think best. From having had no mother to take responsibility off her shoulders, she has grown up to look after herself and has a certain vein of personality which approaches excentricity. This is very attractive to me, but then I am absurdly in love...* They had been living together already for a month, and *the world* apparently kept its opinion of this to itself. Their honeymoon took them to Europe and Egypt; after her death he traveled in the opposite direction.

Clover's condition in 1885 Chalfant presents as the effect of the extra share she took in nursing her dear father on his death-bed. "Tragically," he says, "she was heroic. Other women were considerate and kind, but she was kind in heaping measures." In the summer between her father's death and her own, Clover and Henry spent a month at Sweet Springs, a West Virginia resort, in a cottage by *a swimming-pool of mineral water, which keeps bubbling like an artificial Apollinaris*; they rode out on *hillsides sprinkled with flaming yellow, orange, and red azalea*. They had planned a trip to Yellowstone for August, but *we broke down before we could start,* he wrote to Milnes Gaskell, and they went back to their summer house at Beverly Farms instead. *My wife has been out of sorts for some time past, and, until she gets quite well again, can do nothing.*

Her brother-in-law Whitman Gurney wrote to *Nation* editor E. L. Godkin after her death, "It has been a terrible summer as you know for poor Clover and one can scarcely wish her otherwise than at rest, though we had hoped that the worst was over." Chalfant says without equivocation that she was mad, insane. Other biographers have called it manic depression, or searched for reasons within the marriage—childlessness, or erotic shortcomings, or possibly Henry's affection for pretty Mrs. Cameron, but in his endnotes Chalfant argues for the happiness of the marriage, probing the privacy of nineteenth-century silence for evidence even that the childlessness was deliberate.

Kindness, unmothered responsibility, prolonged closeness to death, short 5-HTT genes—suicide is the hardest of losses to explain. Clover's own biographer Eugenia Kaledin devotes an entire chapter to examining religious, sociological, educational, domestic, familial, psychological, and genetic factors. There were several other suicides in her family, for example, including her aunt Susan Sturgis Bigelow, the Doctor's mother, when he was a small child. In the end, thoughtful and thorough as she has been, Kaledin concludes only that Clover's life was lively and effective, and that there is no "easy explanation." Luggage, Provisions, Useful Hints—there is no *Handbook* for Clover's last trip.

Nervous collapse was the way Adams described his wife's condition in the months before she died: *my own existence went to pieces on these rocks,* he told Elizabeth Cameron ten years later. *In my experience neither rest nor amusement nor absence of care nor the devotion of husband and family nor medical assistance nor friendship nor wealth, stayed perceptibly the exhaustion of nervous energy which was the only real difficulty I had to deal with. All I could do was wholly useless though I knew that my life depended on it.* The structures of her brain too shrunken or disorganized, perhaps, to digest amusement or devotion, suffering neurochemically, she ingested one of the chemicals she used for developing photographs. She had become a skilled photographer, finding the art of it within the complicated technical demands of its nineteenth-century practice; he found her unconscious on a Sunday morning in December, dying.

Everything on Earth

Having lost what was in fact necessary to his existence, Adams's letters from Japan present a version of himself that detours around the helplessness and grief, the inexplicable gap between cause and effect. Only to Hay, who had written praising his novel *Esther* is there a hint of his having carried them with him across the Pacific. *Twenty years ago I was hungry for applause. . . . Today, and for more than a year past, I have been and am living with not a thought but from minute to minute. . . .*

The note that surfaces here, of living from minute to minute, recalls his brief, heartbroken responses to friends' condolences the previous winter. *Wait till I have recovered my mind*, he writes to Rebecca Gilman Dodge; *I am now waiting patiently to see whether my mind will recover its tone*, to Henry Cabot Lodge. *I lie still, trying only not to say anything at all, and wondering how long it will last*, to Senator Carl Schurz. *I admit that fate has at last smashed the life out of me; but for twelve years I had everything I most wanted on earth*, to Godkin. And to John Hay, *I am getting through the days somehow. I count them eagerly as they pass in the hope that each one may give me back my nerve . . . my only chance of saving whatever is left of my life can consist only in going straight ahead without looking behind. I feel like a volunteer in his first battle. If I don't run ahead at full speed, I shall run away.* His pen modeling this tough plastic material, he ran at Japan—flea powder in his nightdress, crumbling *waraji* on his feet— a whole regiment laughing under fire at Gettysburg.

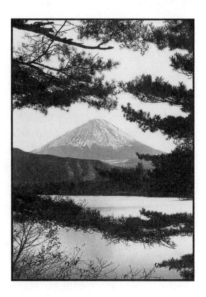

II.
The Measure
of Grief

Genealogy
(January 29)

TWO SCRAPS OF OLD PAPER have come into my possession, along with a very large silk shawl embroidered with flowers and extensively fringed on all four sides. The homely paper rectangles, scissored from larger sheets, tell a scrap of a family story: the shawl was brought back from Mexico by my mother-in-law's great-grandfather as a gift for his wife. This narrative is thickened a bit by the additional information that the great-grandfather was "a breeder of fine sheep and hogs," and Mexico is probably where he went to sell them. So, there was a world back there where some sheep and hogs were distinguished by the adjective "fine," a word you'd expect to be associated more with something like the shawl. Perhaps this creates an implied connection between the two, a one-syllable comment on the beautiful logic of trade. The longer of my two little texts further identifies the livestock as "prize": prize hogs and sheep the great-grandfather "sometimes bought and sold." Further information, in the kind of unevenly inked, typewritten print you never see any more, is that this hogs-for-silk business happened before the 1860s, and we know this because the writer remembers a Mexican grave in the cemetery plot where her parents are buried, the grave of a man who worked on her grandfather's farm "and afterwards was a soldier in the Civil War.

When I was a girl in Canton," she goes on, "there was always a flag on that grave on Decoration Day."

That could be the end of the story—from the transformation of prize livestock into Mexican silk to the patriotic transformation of the Mexican worker. Canton could be in Minnesota, where my parents-in-law grew up, or Illinois, or possibly in Ohio, where I myself now spend part of every year, for there are also family members buried in those states. I know this because the grandmother who labeled the shawl also once busied herself with a genealogical record going back to the Mayflower, which has photographs in it of family stones in one of those graveyards you see on the wandering back roads of rural Ohio. I mention this as background for what is in fact the end of the shawl story: the last sentence says, "Grandfather gave the cemetary lot to my father." Then she signs her name and the date, a winter day about forty years ago. The end of the story is that misspelled cemetery lot, which is always the end of the story, no matter how it's spelled, but in this case it was a surprise to get there so quickly. The other paper, undated, just says about the gift, the hogs and sheep, and the Mexican provenance; it's no more than a label, really. But the one with the story moves through history and memory and by free association back to a war and a childhood, a holiday flag and a family legacy.

Now the shawl has dropped free, clean out of the story and down the subsequent decades to me, undreamed of by Grandfather Joseph Drake or his wife Sarah Vittum or the unnamed Mexican or the fine prize pigs or the writer herself, who was dead before I came into the family although probably not buried in the lot with the man from across the border. More unsettling is the idea that the shawl has not dropped out of the story at all; it has simply acquired another chronicler. I can't even claim to be a less associative writer than the last one, or less likely to be drawn to memories of my childhood or ceremonies having to do with death. Not that anybody gave a cemetery lot to *my* father. In fact, when he died we were so unprepared for such an event that every immediate aspect of his post-life existence was a delicate

negotiation with the practical side of grief. Nothing we did made any sense, from the delay in removing from the hospital emergency room what at the time seemed no longer to be him at all, to the heartbreaking image of my mother in a cemetery parking lot clutching in disbelief the miniature casket with his cremated remains, to the cold bright morning when I said the Twenty-Third Psalm over a patch of turned-up earth in a distant cemetery I'd never seen before. Nearby were the graves of others who had done the same kind of work that he had, which like Grandfather Drake's was international in scope but unlike his did not involve fine farm animals. There were certainly no graves of previous generations of his family, whose genealogical record I'm quite certain involves no historic ships.

Sarah Vittum Drake undoubtedly wore the shawl during the Civil War, and perhaps her daughter and granddaughter during other wars. By that time there would have been the Spanish-American War and the First World War, the Second World War and, well, I guess we're into my lifetime now, the Korean War and in due course the war in Viet Nam, by which event flags were being burned and the shawl would have belonged to my mother-in-law. I didn't ask her if she ever wore it. She might remember if she had, or if it was always carefully folded up with the little typed stories signed by *her* mother-in-law who I think she didn't like very much but still wrote to regularly and did other right things for. Now she is losing little pieces of her brain to a cruel but nevertheless common illness, and I am a little older than she was when I first met her. Today is her birthday, but we think she may not actually know that.

I have taken the shawl out of its wrapping. If nothing else, it won't be a surprise to my daughter-in-law when it's her time to have it. Or, such a lavish display of Mexican silk could be just the thing if I get invited to the right kind of party; if not I can throw it over a piece of furniture and see how it looks in the light of the twenty-first century.

Dixie Diary

NOW WE ARE IN FLORIDA, which turns out to be much like other parts of the U.S. we are familiar with only the weather is a great deal better. It's not spectacular, like the Bahamas . . . well, yes it is, really, if you can think 70 degrees and sunny toward the end of January is spectacular. It's just that people keep saying it's been unusually cold, and the newspaper mentions ways to keep your plants alive in the cold snap. The cold is snapping at night mostly, when it does get chilly.

It's hard when night falls, even though that too is different here from where we came from—it happens later. We are closer to the equator, so the sun has a different arc, and the day lasts longer.

It's hard when night falls because in fact we are in mourning—really, literally, for a death, like in a Victorian novel, only we are not wearing mourning, just our usual clothes, which we brought probably more of than we needed, but when you go someplace unfamiliar where the weather is unknown you have to be ready for anything. We don't have special clothes to mark our grief—dark bands along the hem, or black ribbons anywhere, but it would probably be useful to have them because then people would remember that we are grieving, and their remembering would make a space for our grief. Also, we would remember why we feel this way, and would not be thinking

under our regular thoughts that the others around us are not interesting, or feel viciously indifferent to their conversation.

Here in Florida things are bright and green: the palmettos and the live oaks shine under the sun, which also spills into the room and lights the ocean a few miles away. The Dixie Freeway runs straight and flat, lined with shopping malls and small real estate offices, and places to get something done to your car. They are not ashamed here to identify with Dixie; they are not in mourning for their past, but have forged on into this future of high rise condos on the beach and nautical theme restaurants. Nearby, NASA shoots off rockets to explore space; you can watch this happen quite close to where sea turtles come on shore to lay their eggs. Both of these are considered tourist attractions.

In the old novels when someone dies the clothing necessary to mark it may be a matter of concern because the young widow is too pretty to be hidden away in black bonnets and dark dresses. Or it may be a matter for gossip because of unseemly speed in moving through the gradations of mourning—from full black to a black hem, for example, or a hem that is not deep enough. If the old novelist is Dickens, there may be sport made with the layers of crepe and trailing ribbons, the lugubrious relatives. The nineteenth-century death industry was something to shake free of.

Jews used to indicate loss and mourning by ripping their clothes. Now just the torn lapel is a discreet signifier, or even wearing a little black button with a ripped ribbon hanging from it. The fact is, death does make you feel like ripping your clothes. It's remarkable that this feeling can be contained in a little button and a shred of cloth. A little synecdoche of feeling attached to your still living person.

We have packed our ordinary things in suitcases and come to where our loss and grief did not take place, but we ourselves are quite ripped up even though we forget that we are in mourning until something

reminds us of things that cannot be mended and time that cannot be reeled back. It is so pleasant to be out of the cold that we speed back and forth to the beach with the windows open.

This new landscape does not mean things are any different from the way they were last week. They are quite different from the way they were last year, though. Many of the sea turtles that will come to shore this spring are the same ones that came exactly here last year, but even they are not the ones who left their eggs a century ago, or who came before there was any Dixie. Slow growing, living fossils, coming on shore only to nest and then returning to the ocean, they are as particular as we are, and like them we carry inside us a future that knows no Dixie, no dressing and undressing, no warm days on the beach or cold nights among the palmettos. No sun, no stars thick in the open sky, no happiness or sadness, no love that makes the bright morning hopeful and sweetens the quiet air outside the open door. While we are here we will try to understand this, although in our new sadness it is very difficult.

The Other Side

WHENEVER HE AND HIS WIFE went out to dinner, Oliver told me, on the way home she told him all the things he had done wrong during the evening. It was a regular thing, he said, and he hadn't even noticed the routine until he was trying to get out of the marriage, which is of course a time when a lot of things you haven't quite registered take shape. It does sound quite mad: you spend an evening with friends, and then one of you has a commentary on the other's behavior that has to be shared right away. A replay of your life from another point of view. If marriage can in fact offer another point of view. I guess that would be the wife's point: that his behavior was somehow something she was supposed to keep in line, or that they were lined up together. Something like that.

At any rate, it's striking the way this marital logic disintegrates when subjected to a bare bones description from the other's side of the line-up. Not only does it begin to seem mad, but the line-up itself looks like quite a hopeless idea. For one thing, how many things can a person do wrong at a dinner party? Furthermore, how do you know in fact what wrong is? On the other hand, this is not an exotic impulse. Married people are constantly criticizing each other lots of ways, marriage being the great respite from one's own shortcomings that it is.

Anyway, Oliver had to spend some time really feeling like a putz for having gone along with this nutty practice or else for never noticing, which is actually a form of participation. On close (and expensive) examination, that is, it turned out to have been a shared insanity. And then he got out of being married, which I don't know the whole story of, since by the time he was my friend it was all over, really. He is much happier, and now no-one catalogs the wrong things he does, or if they start up he Just Says No or something so as not to be in that bad system anymore. This is the end of his part of the story.

That teller of the other person what he's done wrong, though; I think about that person sometimes. What it's like to put yourself in somebody else's life, to take his name (a continuing custom), live where he works (ditto), become if not one flesh at least one social unit, part of an even-numbered gathering, your first name preceded or followed by "and" in the thoughts of your acquaintances. Doesn't it naturally follow, then, that if you are dressing to minimize your own bad points you would really feel it, the way he's, say, wearing some shoes that are worn in enough to show the ungainly shape of his foot, or that his shirt just seems a pathetic choice? And if at the party he ignores somebody because he's involved in another conversation, wouldn't you take note of that, or if he bites into a cracker with a topping and it falls all over his pathetic shirt front and the floor and he doesn't even seem to notice? Wouldn't it be your job to point that out? Or if he shouldn't have taken that gooey little hors d'oeuvre in the first place? Or if he talks too much at dinner, takes up more space than seems right and possibly is boring others or tells a story that isn't supposed to be general knowledge or lets on that he (and by extension you) has a low opinion of someone who is a good friend of the host? What are you supposed to do, just pretend it has nothing to do with you? What did he give you his name for if he wasn't looking for this kind of feedback?

There are lots of self-help books about this stuff, but what if you are the only one reading them, and he is relying on you to help him? How are you supposed to do it, by mental telepathy? So you open

your mouth while the catalog of errors is still fresh in your mind and you ease the humiliation and anxiety of having watched him make these mistakes all evening by sharing your observations and opinions. In the dark and private space of the car you can come together with him, relieving yourself of the loneliness of watching him out there for so many hours not thinking of you or of aligning with you. He listens and doesn't say much. Oh, occasionally a mild protest, or even an agreement that something was a mistake. Sometimes a fight, but mostly just going to bed as usual or, lighter now, you move on to other topics—somebody else's indiscretion, or happy future options for using your frequent flyer miles.

And then one day he says he's been really depressed for ten years and he doesn't want to be married any longer. He has flown off on his own now and whatever is wrong with him he will be taking along. That's not what you meant, but there it is—or rather, there he isn't. It's not fair because there's no way you can get back all that careful observation of another human being, get it back to turn to your own benefit if necessary. It's been lost time and attention: while you were taking all those careful notes the story was unfolding around you along quite an unexpected trajectory and now the plot is pretty much out of your hands.

Now those intimate homeward journeys are stripped of your motives and history and feelings and cultural moment, and they look very much like a perfectly crazy way of relating to another human being—if not a downright expression of hostility. What I'm thinking is, the whole system of even getting into a situation where there are two sides trying to line up as one is a juggling act heading for a pratfall.

The fact is, I am very happy for Oliver that he is out of this marriage that made him so unhappy. Everything changes. I just wonder about the story, how the shaping of things is so much what reality seems to be. All shapes, I mean, are unstable but when they are handed around for other people to feel and to look at they seem so firm. A perfectly nice-looking person with an engaging laugh and a lively

manner can be caught in a snapshot looking stiff and predatory—
that happy, basically innocent laughter a screw-faced, ugly-toothed
image with the nose somehow highlighted, and the wonderful joke
inaudible.

My Depressed Person
(A Monologue)

A FRIEND RECOMMENDED A STORY by David Foster Wallace called "The Depressed Person." My friend has never been really depressed, although she is well aware that depression, psychotherapy, mental instability, clinical diagnoses, crazy behavior, internal pain, lack of self-esteem, alternative therapies, crystal-gazing, the whole nine yards of contemporary malaise and its panaceas are all around her. A keen student of her culture, she admired this story because its language is so dead-on, pulling you into the perplexed vortex of psychotherapy. I know that others have found this story insulting to that practice, but when I read it I did not see it that way, nor do I now, even knowing that in none of its manifestations was Freud's proliferated legacy able to save the story's author.

What I saw instead was a brilliant narrative (if something so painfully circular can be said to be a narrative at all) driven by an enactment of unremitting self-consciousness. Its forward motion proceeds at the pace of therapy, which is to say in a series of repetitions and involutions that border on the grotesque; a few developments along the way tug you forward, while the central character, the depressed person herself, never moves off the dime. No matter what happens she is at the bottom of a well and all she can see hear touch feel taste

smell is herself. The brilliance of the story is its double action: the free indirect discourse of excruciating self-centeredness and the linguistic play around its ouroboric tedium. Reading it was painful and fascinating. First, there's the digressive style, and then the interminable footnotes that keep interrupting the flow of the narrative, which as I said is not flowing much at all. It's a problem, keeping the different tracks running along at the same time, jumping back and forth and up and down on the page. At one point a dramatic turn surprises the loose shape of the story, springing open the traps of self-centeredness and skepticism about psychotherapy and other professional healing techniques for mental anguish.

That's almost all I want to say about the story, because what really made it so riveting was my own intimate and long-term association with a depressed person, someone I cannot do without in my life, who because of an unforeseen event in *her* life fell into a terrible condition and was physically and mentally down that bottomless well. Because we are so close, it was my experience too, and so there I was in the middle of what I first heard about in college as the mind-body problem, which is to say that it got to be hard to tell what was her and what was the depression, and where they were the same, and who or what exactly I was relating to or loving. I was part of it for two years (and I will add here that depression seems to me contagious although not exactly like flu or measles) but it was only toward the end of it that I read the Wallace story, not knowing, of course, how near the end I was, even though by then things seemed to be looking up.

•

Reading the story again when that time was over, it didn't seem as long or as familiar as it did when I was still in the world of a depressed person, that terrible hole of the self's dark side. What I noticed later was how different my depressed person was from the one in Wallace's story, which still seemed a dazzling performance of the way the depressed mind works, its enactment of intense mercilessness. What

was the same was the terrible self-referentiality of the disease, the shame, the sense of being demeaned, the conviction that no one else has ever suffered comparably, the inability to describe the actual pain, and the isolation.

OK, I have a little more to say about Wallace's story, which is that now I think it's more about the relationship to the therapist, which in this case ended with the therapist's suicide. Then the depressed person starts calling an old friend long distance who has some kind of fatal cancer, so she's probably going to die as well. This unexpected (indeed, over the top) deployment of transference goes beyond contagion to understanding how depression is a struggle with death. The story is not only not insulting to the professionals who take on the job; in its dark and comic virtuosity it speaks its knowledge of the highest stakes. While I was caring for my depressed person it was as if the person I loved and depended on for so much of my life had been taken away from me and I was just hanging on to this vestige of her that I was blindly sure would turn back into the normal person she had once been. There even were times when she was that person, and I'm pretty sure she sometimes saw her real self too.

•

Her therapist had moved to California several years prior to this very bad time and although available on the phone was unable to be part of her therapy at anywhere near the level described in the story. Other local therapists were unconvincing. Once I drove her out to a near suburb to see a man who had been recommended. It was a warm summer day and when we got there I sat in the car and read a book that happened to be on the dashboard while she went in. I left the car door open and occasionally my gaze would drift around the little parking lot of the mini-mall where the therapist's office was. I was a little distracted by anxiety about where we were going to get some food. One other thing about her depression that was not part of Wallace's story was that she needed to eat all the time. Not

neurotically or for comfort, but because it reduced the depression. She
had been on Prozac for eight years, but then it stopped working and
nothing else she tried worked either. Sometimes she'd try a new drug
or homeopathic remedy and it would work for a day, after which she'd
crash even worse, which meant for me she was totally gone, dazed,
unaware almost of who I was, of my love for her, of the chair she was
sitting on.

It gradually became clear, however, that when she started sliding
in this direction (tears dripping, loss of attention, a strange silence)
if she ate, this slippage would stop. Food turned out to be the only
substance that worked consistently and without the side effects of a
crash, or insomnia, or a weird buzzy feeling. Even natural stuff like St.
John's Wort or other liquids in expensive little bottles with droppers
had those effects; also the latest SSRI breakthrough. A top man at the
top loony bin in the region recommended something that came in a
big bottle and looked just like mouthwash. The first day it made her
feel better. The second day she wandered into the living room and
when I sat next to her on the brown couch under the window she
hardly knew I was there or if she was. It was like talking to someone
dangling over a cliff and trying to get her to hang on until the rescue
team (nowhere in sight) arrived.

But food worked fine except of course for its own side effect, the
weight gain, a porking up that was its own misery. Also, there was the
relentless need to keep assembling food. You have no idea how hard it
is to feed yourself a hearty meal seven times a day, particularly when
you aren't feeling hungry and are in a complete swivet about the size
jeans you now have to buy. Even for the two of us it was too hard. You
have to keep thinking of what to buy and then what to do with it.
Plus she wanted the food to be healthy and not fattening. Apparently
the last thing to go when you are hanging off a cliff is anxiety about
whether you're fat or not. This is a twist in the mind-body problem
not taken up in past study of ancient philosophers, but nonetheless
part of this story.

Waiting in the parking lot of the mini-mall I took a brief and

secret pleasure in the skimpy flowering trees at its edges. After fifty minutes, my depressed person came out of the therapist-possibility's office and sat next to me in the front seat of the car. "How was it?" I asked. She snorted with laughter. "He thinks I'm a codependent maniac," she said. He'd had some other things to say as well, all of which shed new light on the situation as almost everything did, the situation being so very dark. We got some take-out sandwiches from a local restaurant and went over and over this new information as we drove to a nearby meadow and walked its trails through marshy places, through woods, and along a bike path. We took our water bottles and ate the sandwiches, but it's our laughter that I remember.

•

As the months went by she saw other therapists and tried other remedies. I talked to a highly qualified medical acquaintance who explained to me the vast superiority of ECT over anything else in curing depression. That means electroshock therapy, and we didn't go there. Even depressed, her brain is way too important for that. They don't know why it works, this high-powered psycho-medic told me, but we don't know why aspirin works either. On the other hand, I never knew anyone who actually said they were helped by having their head hooked up to electrodes regularly for ten or twelve weeks and losing bits of short term memory, but aspirin I've tried myself. She ordered a book on the subject, which I read. It had pictures of electricity patterns rendered as squares, and neat profiles of patients the treatment would be good for. I couldn't see my depressed person anywhere in this text.

Once we visited a place that had been set up to be a friendly refuge for traumatized women to come and recover. They had groups all day long, which unlike the depressed person in the Wallace story my depressed person actually likes. She knows how to be in groups, how to listen and to share and to have informal fellowship afterwards and to believe in the contact. So we were shown around this facility and saw the little white beds and the collections of stuffed animals

some of the women had, and peeked into a room where a group was in process.

That day I was actually in worse shape than my depressed person. I was worn out and sad from all the nights of watching her suffering and the mornings of going to her house to get her out of bed where she was envying the dead, and talking on the phone and in restaurants analyzing the terrible precipitating event, which if you are curious was the end of a long marriage, but believe me it was the marriage and not the ending that had wrecked the serotonin re-uptake process. I wanted to talk a little more to the counselor who had showed us around, but my depressed person just wanted to get out of there. She couldn't see herself in one of those little beds or hanging out in those narrow halls. Which I could understand. It was not a cheerful spot, and they didn't seem to get it about the food problem.

•

She tried a lot of other things. She wasn't unwilling to exert herself to help herself. She drove all over the place seeing an acupuncturist and a guy who did something to her spine, and a woman who proposed to cure depression by following eye movements. A homeopath wearing orange spectacles demonstrated how her muscles responded of their own accord to disturbing prompts based on the parts of her name. Everything worked and nothing worked. Time went by, and the fact of all this therapeutic culture out there offering hope and taking money and available for the client's evaluation was part of the time, part of what there was to do. Once someone came to the house and tried to help her get in sympathy with the cells in her body. This someone, who worked with heart patients and cancer patients in hospitals, had had measurable medical results from getting people to be in touch with their prenatal lives, when their fetal selves were being impacted by what was going on ex-utero and thus messing up their little cellular psyches. I had to leave the room while this was going on, even though it was an acquaintance of mine who was practicing this

peculiar art and it had been my idea to have her come. We are talking desperation here, it must be obvious. On the other hand, there's also the mind-body thing, which is not just something that went out with Lucretius or Parmenides.

•

Anyway, you can see that the day when we walked around the meadow and laughed at what a codependent maniac she was stands out in my mind. It's not the only day of course, and I never really lost sight of our laughter. I have known my depressed person since she was born and if she slipped away from me I would not be myself anymore. It's just that if the effect of depression is this terrible self-devouring, self-centered blindness, the only way to be myself was to approach that center with her. Which brings me back to the terrible gift of David Foster Wallace's story: his knowledge of what it is to be lost to the grace of compassion. Choking on her own tail, in the hell of self-enclosure, his depressed person couldn't see that her center was shared and so her behavior is figured as grotesque, revolving alone in the same spot. Ouroboros. Just so do the ceremonies that deal with depression come to appear grotesque (like those in other cultures, witch doctors and couvade and voodoo)—first comic, and then deadly.

And yet the story is alive and funny as well as grotesque, its dark art lit by the cosmic comedy of our imaginary separateness. Which is surely why my friend recommended it. She is quick and funny herself and appreciates life and humor in others. And so is my dear depressed person quick and funny even though a codependent maniac, so our walk around the meadow with our water bottles was really fun and I was absorbed and amused by her story about the therapist and his new information, his perspective on her case. I bet he would have been surprised to see us enjoying our walk, although perhaps not. Freud himself, after spinning out one nutty (although interesting) theory about the death instinct after another—and actually calling the essay "Beyond the Pleasure Principle," which makes you think

it's going to be about some higher fun—essentially shrugs his shoulders and says, "What we cannot reach flying we must reach limping." And, if you were wondering, that sudden, expressive freedom of gait is what I mean by the grace of compassion.

So, imagine us limping around the meadow and along the bike path, tracing a narrow road inside the borders of the pleasure principle, while all around us time disguised itself as catkins and marsh plants and former children whirring by on rollerblades. Imagine my depressed person's serotonin levels responding to the burning of calories or to the invisible planetary alignment over our heads or just to our being together in our own long, digressive, circular, and finally shapeless story.

Not Exactly Kaddish

IT WAS THE WORST THING, your sudden absence, the fact of death so unreasonable, so enormous, so unnecessary. The November night, and then, later, unbelievably, the sun up over the little woods behind your garden, the next day emerging into a future in which you were the past. Suddenly so much revealed, and so much business—legal notification, funeral home transactions, religious questions, financial considerations, food, ceremony, phone calls and old friends and weeping—so much business to keep us busy, and then forever the bare fact, over and over.

Since you died the sun keeps coming up, more than nine thousand times, which when you put it that way doesn't seem so many, the way the years slip by into these numbers, but the boy who was only nine when it happened (and even a little excited by the dramatic family event) has become himself the father of a boy just starting to talk. "All gone," he says, holding up his empty sippy cup. All gone as we are all going, but I didn't know that before you died and now it has settled into my blood and the world you left and we ourselves are quite different. It is twenty-five years now, a lifetime or more for half the people I see every day.

I have in my wallet a helpful card I got from another funeral home.

It has on it the mourner's Kaddish prayer: unintelligible Hebrew on one side, unintelligible transliteration on the other. *Yis-ga-dal v'yis-ka-dash sh'may ra-bo, B'ol-mo dee-v'ro hir-u-say...*the inverted commas and hyphens are marking something missing, I guess, as you are. I cannot learn it; I never heard you say it. I have been in circumstances where I've heard others say it, a rhythmic chant that goes on and on until grief becomes just syllables, language out in the breathing air, and I think of you. I think of you then, and when the November light slants across my slowly disappearing garden, the short short day putting out its most brilliant moment on the scattering leaves. Every death is yours.

Grace Paley Reading

GRACE PALEY IS READING A STORY for a large (off-camera) audience. She stands at the lectern, white hair an untidy nest around her now aging face, large spectacles over her eyes, and some kind of colorful scarf hanging like a prayer shawl around her neck. She is reading a very good story about four old friends, one of whom is dying. The others are visiting her in the hospital, and then they go home to New York on the train. They have mostly grown children (one dead already). The hopeful troubles of political and erotic trying are part of their personalities. On the train ride we see how different they are, the three women who are not dying yet. The narrator is named Faith, a sort of stand-in or useful companion for Grace, which I have always thought was a lucky joke, in all the stories where it comes up, those stories that ride the line between fiction and nonfiction. Those stories that come out of real life so beautifully scrambled into language that they can be called fiction.

This story includes details about the train's wheels even, their imperfect relationship with the tracks, which I'm sure she just put in because she is a good observer of the world around her, its linked absurdities and difficulties. But when you think about it, you can see that it's a sort of parallel to the way the women friends are with each

other—not entirely in sync, but old, old friends who cannot really run without each other. And in a funny way, it's as if Faith has sympathy for the groaning complaints of the machinery, because the friendliness in the story is so enormous, encompassing as it does so much discord and unhappiness, as well as love and loss.

Grace Paley just reads; she does not look up at her audience or tell them little stories about the circumstances of inspiration or other auxiliary anecdotes. When they laugh—which of course they do, because this story of grief and argument and growing older is also funny—she smiles and pauses. Her smile is lovely, so very pretty—it is young and shapely, and it was the first thing I noticed about her long ago, the very first time I saw her read, when she was not as well known as she is now, and the audience, though enthusiastic, was smaller than the one I can hear is out there in front of her. She came onto the stage, small, a bit disordered, wearing red shoes. Then she smiled and I lost my heart, as I already had to the stories in her two books, then recently published, and as I already had to the person who first read me a story from one of them. We were lying in bed, even though we had only recently met.

"There were two husbands disappointed by eggs," he began. Isn't that a great line? I had only recently stepped away from a husband and was living in the windy surprise of a house without a roof. This voice sounded like home, a surprise of my own. In it I freely contemplated the wrongness of husbands without losing the possibility of rightness, and breakfast.

In the video I am watching, she scratches one upturned palm as it lies on the lectern, absently, a small gesture to keep herself aware, maybe, as she reads. Or an unconscious self-consciousness. The last story she reads is called "Mother." It's very short and I know it very well. But it sounds different as I watch her reading—longer, and as if it has in its plain and still surprising language all the things I can think to say about it—have said about it. Her mother was dead when she wrote it, and it starts with a kitschy line from a song, about wanting to see her mother standing in the doorway. Then it turns into a

whole history of family and immigration, culture and politics, memory and loss. When you can't see that it's only one page long, you think it's a big story, even though it only takes a couple of minutes for her to read it. You see that she has done something with time in the story so that the space it takes up in print slips away from the usual measuring tools: paragraphs, line-inches, pages.

She is still standing in the doorway, is what I see, even though since I watched that video of her she too has died. The last time I saw her she had come in cold weather to take part in what without her would have been simply a poorly organized and rather foolish event. In a crookedly perched knit cap and snow boots she stood up out of her unyielding illness and surprised us and herself into the unmeasurable laughter of being. She is still standing in the doorway, still offering what seems to be something as simple as eggs, but is actually as complicated and endless as language, and faith itself. Faith herself. I am still watching her: the modest way she stands, her occasionally curving smile, her stories that leave their endings unfolded, even when they are deaths.

III.
At Liberty

Eggs

PETER IS TRYING TO FIGURE OUT how to create a structure in which to drop an egg from a fourth story window without breaking it. His favorite plan so far involves two frisbees, some bubble wrap, and a complicated arrangement of springs to absorb the impact of the fall. The frisbees (or *frizbes*, as he spells it) is the part of it I'd never have thought of. They make a curious clamshell ovoid and they are only part of the reason I find this project hard to relate to. Why would you want to drop an egg from four floors up if the point wasn't precisely to see it smash? On the other hand, Peter is excited about solving the problem and has a whole page of mock-ups, including a key to understanding the materials—springs, tape, frizbe—so I am giving this my attention.

What makes an egg crack, says Peter, is that when the bottom of it hits the ground the top is still falling. He showed me with his hands. Later that night I wake up crying out in terror, in protest. I've been dreaming I was in an elevator full of people that was descending way too fast. Faster and faster, in fact. Having now developed some interest in the issues of how to lessen the impact of an illogical fall, I was at first scheming to hang my legs over the handrail running around the walls so that when the elevator hit, my body wouldn't crash into itself.

I heard once about a woman who saved herself in a similar situation by grabbing onto the molding at the top so she was off the floor on impact. But the other people in the elevator are screaming and, now hanging in a contorted position with one leg over the rail and no faith in the physics of what may or may not happen, I want to join them. Now, my desire is to do what the others are doing: to cry out in protest, to go down screaming for help with my fellow travelers.

What about just hard-boiling the egg? I asked Peter, but he said no, it had to be a raw egg. There's an old story about Columbus and a hard-boiled egg—he figured out you could make an egg stand upright if you simply hard-boil it first and crack one end, thus confounding a room full of smart fellows who were for some reason confronted with this problem. Possibly this is only a metaphor to demonstrate the kind of out-of-the-box thinking needed to discover America. Five centuries later the box has been replaced by a couple of frizbes but the setting of pointless riddles about eggs to particularly intelligent people retains its appeal.

I think the art of boiling an egg, while perhaps entirely off-message and perfectly unspectacular, is nevertheless a useful application of physical principles. When you finish knocking their socks off or exploring the collapsing enclosures of your own psyche, you can peel it and eat it for breakfast.

Tapping Back

I KEEP FALLING ASLEEP OVER PROUST. This is very disappointing because I love Proust; I love the long sentences and the analysis of the social zoo and the observations about memory and identity that seem to drop me into a deep well of meaning, an unfolding, illuminating darkness. Like his digression on waking from a deep sleep, for example, when, he says, we search for our thoughts, our personality, as one searches for a lost object. Why, he asks, *among the million human beings that you might be* do you lay hands unerringly on the person you were the day before? He compares this to a resurrection, and to the action of recalling a forgotten name, or line, or refrain. *Perhaps the resurrection of the soul after death*, he murmurs at the end of the paragraph, *is to be conceived as a phenomenon of memory.*

I think Proust likes the possibilities for self-abandonment offered by sleep, the game of death and resurrection, although I'm not sure he would include this napping over his own oeuvre. As it happens, for me the passage coincides with a resurrection of Proust himself from a two-year gap into which he fell thanks to an emergency that broke the spell of the page. Now I was hoping to lay hands on the person I was before closing the book, to repair the rupture in Proust's narrative flow, to simply slip into the back and forth motion of his sentences,

knitting up past and present so that even the dropped stitches fit into the pattern, and perhaps at the same time the rupture in my own life would turn to some advantage as yet undiscovered.

I recently found a scrap from the other side of that rift, a page in my own hand reaching toward Proust as his young Marcel wakes in a hotel room by the sea. A child still, Marcel was not reaching for the person he was the day before, but rather for his grandmother, in the bliss of being wholly and solely in her affection. This is the passage:

> sweet morning moment which opened like a symphony with the rhythmical dialogue of my three taps, to which the thin wall of my bedroom, steeped in love and joy, grown melodious, incorporeal, singing like the angelic choir, responded with three other taps, eagerly awaited, repeated once and again, in which it contrived to waft to me the soul of my grandmother, whole and perfect, and the promise of her coming, with the swiftness of an annunciation and a musical fidelity.

I had thought this clause, unrolling behind a semi-colon, was really over the top. Talk about resurrection! The kid wakes up and he's in heaven: *his tapping, his self-noise, turns the wall of his bedroom into a musical instrument,* I had written, *a choir of angels, a song of religious ecstasy, a musical moment in which promise and fulfillment are the same.*

Favorably stirred by my own response, I found myself nodding approvingly at the person I had been two years before—inspired, even, to pick up the skein of thought, to cast onto the needles of my former self a few more rows. *The musical awareness creates a time-based eternity,* I scribbled (meaning, if promise and fulfillment are the same, he's in eternity, only you can't have music without time). *His grandmother's love for his particular self frees him from its particularities, as musical timing takes its listeners off clock time.* As indeed this written language was doing to me, wafting music and annunciation, love and joy, into my reading moment—the happy result of not falling asleep.

So, that's good for Proust—the language is his symphony of consciousness, the particular noise he can make. But what about the reader? How does the reader, quietly knitting Proust's language into her afternoon, become part of this sweet morning noise? The mystery of reading is the way it puts time in your hands: you can go back and read the sentence again, make a few notes, stop, and start again two years later without interrupting the melody. Nor had the passage of time lessened my desire to just tap back at an imaginary Proust, to become lost myself in the sweetness of the choir. Where was *my* faithful, annunciatory grandmother, that mirror of blissed out tapping—oh, never mind the grandmother (who off the page and past the age of three or four has such a relative, anyway?). The point is, I had had something to say back to this passage, my own little song to play on (to dissolve) the partition between reader and writer.

It was a song about art, about a conversation that collapses identity. Getting lost in another's language just shows how permeable an identity is, one's dissolving self. We are here in the lamplight and there in the morning bedroom—or rather, there with some imminent presence, the writer, who is in fact dead, but nevertheless comes to the reader whole and perfect, dissolving the thin wall between past and present, incorporeal him and still-fleshed you. He taps; you tap back; angels sing.

OK; it's just reading, but still it's a good idea to stay awake, keep your place in the text: angels, identity collapse, and inevitably the particular annunciating angel, the grandmother, is going to die. Now I really wanted to remember—to pick up the relationship, to be freed again into Proust's symphonic, incorporeal tale. Unfortunately, I was having some trouble unerringly laying hands on what had been going on when we last parted—that passage about tapping on the wall was in Volume I, and my bookmark was well over 700 pages into Volume II. Oh, some complicated social interaction among the French noblesse, some awkward leave taking or unsuccessful dissimulation of motive, with an erotic bass line.

My decision was to show up as if nothing had happened, to vaporize the lost two years, as if I'd just stepped out to the corner for a pack of cigarettes or maybe to mail a letter, since I don't smoke. If the truth be told, this wasn't the first time: three decades ago I'd been falling asleep over Proust but I was pregnant then, and young, both of which seem to be conducive to falling asleep over great literature. After pregnancy came many other things that were incompatible with long sentences and symphonies of consciousness. I was gathering and losing a past of my own.

Proust says we think all our past joys and sorrows are perpetually in our possession, but whether that is true or not, mostly they are in an unknown region, where we're unaware of them. When the *sensation context* (that would be the madeleine dipped in the tea) is recaptured, however, they return with *the power of reinstalling alone in us the self that originally lived them.* We become, that is, somebody we used to be.

This is a very big idea, although most people have probably had that experience without exactly knowing it, maybe while listening to music, for example, which is famous for slamming you into the past. Only, often what gets retrieved is not really the self that originally lived it. Take Schubert's Adagio in E flat, at once exquisite and unbearable because it sounds like an unutterable and utterly lost happiness. It comes from a wordless unknown region where there *is* no particular self to be reinstalled, no matter the cascade of associations. It feels like lost time itself, and getting even more lost as you listen.

How different this is from picking up a book after a long absence. A book is not a sensation context, and its best hustle is the way it seems to erase time. Reading is a willing submission, a happy dispersal of self. Self, with all its grubby limits, its always smudged present and its inevitable blank future. Now, when I dislodged Volume II from the boxed set what was reinstalled was not my vanished and pregnant youth, but the hotel room with the melodious wall, which—uncannily and more than a thousand pages farther on—just so happened to be recurring in Proust's narrative. As if a question had been answered

(*this is where we were*). As if Proust had been waiting for me to return. In spite of the napping, in spite of the long abandonment, that hotel room on the beach was still there. And it was Marcel who had taken the hit, gotten older, suffered loss, even though as I leaned over with him to unbutton his boots I suddenly knew just what was going to happen there.

Disruption of my entire being, says Marcel. The place brings back to him his grandmother, dead for a year, as a *living reality in a complete and involuntary recollection.* Adagio in E flat for him, but the past triumphantly recaptured for me. Reading, barefoot myself, I fell freely into his sensation context. Miraculously, he was picking up the conversation not only exactly where he had been with his grandmother, but exactly as he had been with his sleepy reader.

The phone rings. Then again. A sharp rebuke. Unwillingly groping for the person I had most recently been, I pick it up. It's my mother; my mother wants me to come for dinner, to commit myself to a day. Meanwhile, with his newfound grief at the loss of his grandmother, Marcel is suddenly understanding the grief *his* mother has been feeling all along. His sorrow, he says, opened his eyes, and *with horror* he realizes her suffering. He understands that *the blank, tearless gaze . . . that she had worn since my grandmother's death was fixed on that incomprehensible contradiction between memory and non-existence.* I underline *that incomprehensible contradiction between memory and non-existence.* He just means that someone so present in memory can't also be non-existent. Unless you are Proust, making memory into a timeless medium, turning a wall into a musical instrument, dissolving grief into language, returning the dead. Awake now, I agree to come to dinner and return to the page.

Tenderly Marcel contemplates his mother's accession to his grandmother's interrupted life. *The dead annex the living who become their replicas and successors* is the way Proust begins to describe watching his mother turn into his grandmother, the way the Duc d'Orléans might become King of France (meaning unquestioned succession).

His mother drops the *mocking gaiety that she inherited from her father,* picking up instead her mother's bag, muff, and volumes of Madame de Sévigné. In this way, he says, *the dead continue to act upon us. They act upon us even more than the living because, true reality being discoverable only by the mind, being the object of a mental process, we acquire a true knowledge only of things that we are obliged to recreate by thought, things that are hidden from us in everyday life. . . .* This is a troublesome thought—that reality is loss recreated, something discovered after it is gone; that *true knowledge* is always after the fact. Always after loss, as in Vladimir Nabokov's recreation of his own lost existence: in *Speak, Memory* the only reality of his own story, of the past itself, is the language into which it is put. Death and loss must yield up the treasure of the past in a resurrection obedient to the spell of the page. Only memory speaks.

Well. Quite the symphony in a minor key, isn't it. Only, as it happens, Proust is no one-key Johnny. His own reminiscent grief is marked by no abandonment of gaiety. In that lovingly described maternal repetition compulsion Proust hands off to his mother a sorrowful trajectory toward a fixed identity: her grief a noble homage paid the mother by the daughter, a million filial possibilities succeeding to one. On another track of consciousness, however, his mental process is observing a different reality: the hotel page who *had no other occupation in life but to take off and put on his cap, and did it to perfection.* In this three-fat-volume recreation of social and emotional life, true reality doesn't accede to anybody else's interrupted life. Everyday life here seems full of gaiety in the moment. Which brings me back to that ringing phone.

I do not want to succeed to my mother, to contemplate tenderly her grief, or ever to drop mocking gaiety and pick up some moth-eaten old muff. I do not want to be annexed to or replicated in the dead. What I want is the kind of digressive freedom mentioned above, the pleasure of uploading awareness of past and present whole and immediate into language—even while drifting on a gray awareness of rain on the skylight and the muted scraping noise of ice being shoveled off the sidewalk below. When Marcel, suffused in that hotel room with

memories of his grandmother's last days, her illness, his failures toward her, his loss of her love, is joined by his mother—by divine right of daughterly inheritance the true mourner—he becomes a sort of method actor, whose *new-found grief enabled me to talk to her as though it had existed always.* Just so does memory free him to slip back into the pleasure of art: not only to see the comedy going on around him but, as an actor now, to reimagine both grief and the very world in which it is occurring. The hotel, he says, was arranged like a theater in which

> the visitor, although only a spectator, was perpetually involved in the performance, not simply as in one of those theatres where the actors play a scene in the auditorium, but as though the life of the spectator was going on amid the sumptuous fittings of the stage. The tennis-player might come in wearing a white flannel blazer, but the porter would have put on a blue frock coat with silver braid in order to hand him his letters. If this tennis-player did not choose to walk upstairs, he was equally involved with the actors in having by his side, to propel the lift, its attendant no less richly attired.

The point seems to be that the terrible losses we have to sustain are going on in a theater in which tennis-players in white flannel enter and exit, a theater in which we are extras to the person who brings our mail. Even as I am upstairs napping over Proust, dealing with the phone call, and trying to lay hands on my own identity, to the man slipping the offers from credit card companies and shopping services through the mail slot I am merely Occupant, someone cast in a hurry to fill that particular house on his route. A comic character sometimes glimpsed in a red bathrobe at two in the afternoon.

Occupant: the impermanence redundantly marked by the round empty zero of the initial letter. The comedy, you see, goes on even as we are creating reality from our losses, wake day after day from sleep and resolve our memories into identity. Our lives are not only recreations of things hidden in everyday life, narratives that allow us simultaneously

authorship and centrality. *True knowledge* is also an escape into theater, where it exchanges the solemnity of succession—and perhaps even of resurrection, of identity—for the joke of repetition, of role-playing. Even Proust, his flying thoughts overcoming his cork-lined death, must fit into my story of reading and napping and filial ambiguity, even if he has to put on a blue uniform with silver braid to do so.

There have been losses in my family that seem to quiet even angelic choirs, events to put the soul to sleep, silence comedy, make memory a vampire of grief. There are also potential losses, unimaginable, desperate losses to come that cast their shadows into the present like the brief raking light of an early winter morning, jagged counterpart to that lovely glow on bare trees and snow and clapboard of an early, lingering sundown. The loss of a past self is a death always in progress, the morning dying into afternoon and night. Even so, *true knowledge* is social comedy side by side with Marcel's deepest feelings of loss. Sleep may occur even in the company of this mind at once entertaining and profound, focused and diffuse. Virtuoso illumination, accompanied by Schubert, by three taps on the wall, by the beautiful language of the literary dead, comes and goes whether we are reaching around for who we were yesterday or not. Even Somnus is supernumerary, I added in the margin, watching the mailman in his snow-braided blue coat stuffing letters into the box across the street.

What It's Like in Ohio

THE FIRST CROW TEARS INTO the quiet evening, harsh and noisy, a black sound, and another one, farther off, responds. It's a horrible noise, unstoppable, and then it stops. The first crow again, then another, and another. They are conversing, relentlessly chatting. Calling on and on, back and forth. It's unmistakable now, a moment of grotesque sociability in the branches, unseen in the leaves. Like scavengers in fiction, funeral buzzards around a dead mule, ritualistic, hierarchical, they have business together. Or gossip, or actual news. They are exercising their ugly throats, the power of their rough voices extending through the neighborhood, hegemonic, a net of communication, speech sounds flying free until they take wing themselves, still caw caw cawing into more distant trees.

When we're in Ohio we are in a world of animals. The groundhogs get close to the house now, and dig big holes near the foundation. First there was one by the front steps; this year there's one under a back window, possibly an opportunistic burrow taking advantage of a recent excavation for an Internet line running through the backyard. A groundhog is a quiet but ridiculous mammal—fat, ungainly, always waddling, nosing, too much fur, too much business altogether and we

are not squeamish about having this intrusive neighbor removed by whatever means necessary.

Nevertheless, we imagine ourselves living here in peace and friendship. Sometimes great herds of deer stream across the lower field, coming out of the woods and then back in on the other side. It's mysterious because the woods are not deep, and while they are obviously adequate for the crows, and make a fine green backdrop for our view, they are not much of a forest shelter. The deer graze like cattle in the field, nibbling with bent necks, or they bite at the branches left dangling from one big tree after a serious summer storm, or nose the old peony hedge in the lower field, a relic from earlier days when there was a house down there, or a barn, before the fire, before our time. Quite often they are in the backyard, very close to the house, right out in the open, or eating the vinca plants around the driveway. They pause to watch as we drive up, their ears stretched wide when they lift their heads. Sometimes they are half-invisible in the trees, something you notice with surprise, a little jolt of interest as the quiet shape is suddenly moving behind a dead trunk.

This fall there have been three little spotted fawns stepping around the property, under the fir trees and along the raggedy late wildflowers at the edge of the yard. At first we only saw the fawns with an adult deer, but now they seem to have the run of the village. The other evening one rustled the underbrush at the edge of the road, all by itself in the thin volunteer trees, eating of course. As I walked by it turned and looked at me. We were so close. And I stopped and looked back, and murmured something friendly because it seems odd to be living near to these creatures and not say at least hello, the way we do here in Ohio, even to people we don't know.

What I imagined was stepping through the weeds and brush and touching the little deer, although I knew it would run if I went closer. So I just stood still and it lifted a hind leg and scratched its ear, like a cat or dog, only with those long slender legs it was so undoggy, the casual three-legged balance, the hoof idly, perhaps even unconsciously, removing the little discomfort from a part of the body it

ordinarily would have no relationship with. Then the young beast resumed snacking and I kept on up the hill.

Another evening, on the same hill, a wild turkey suddenly hurried out of someone's front yard and across the road into a snarl of weeds and branches on the other side. This was a less relaxed encounter for both of us. The turkey had so little aplomb, its long neck stretched forward as if that would get it to the safety of the other side faster, its oval body trying to keep up, its tail feathers a sort of afterthought, dragging behind the hurrying feet. This nervous bird knew I was there and substituted ungainly speed for invisibility. Possibly it was lost and panicky without the rest of the gaggle. Usually the turkeys are sighted in groups, appearing out of nowhere, necks sticking up from the long grass, parading in a slow line as if we did not exist.

On the road at night our headlights sometimes light up a dead raccoon, its open eyes two bright reflections, staring back into the dazzle from the still body with its neatly folded front paws. When we turn onto the dark driveway the nearby deer turn mildly, legs spread and their eyes, too, briefly alight. They don't run, not on our account, although in daylight they'll stream across the field or bound into the woods, tails up, showing that patch of white. But not because of us.

Once I saw them race across the field reflected in the mirror on the bathroom door, through the leafless trees of late autumn. I was looking at my own face, and suddenly there was some wild motion behind me and when I turned, in the far distance a dozen animals crossed the open space and disappeared.

On the other side of the village there is a bigger woods, and a more deserted field. I don't know why the deer aren't there, where there is shelter and quiet and no asphalt, plenty of good nibbling and the insects singing in the afternoon heat. But they are not there; they are on our side; they are in our yards and gardens and tree lines. They don't come for any crops or special things we've planted, they come to our weeds and disorderly bushes, stepping into the shadow of the house as it lengthens and shifts. In the morning almost under the kitchen windows is an apparent family having its breakfast in a

companionable spot. A hummingbird pauses in neutral by the feeder, dips its beak twice, and turns to face the window glass, a tiny blur moving in all directions at once, gone in an instant. We are not who we think we are, with our white-painted buildings and curious eyes, turning our faces to look at them, as they do to us, listening vaguely as if it were we who are the shy ones, and they the ones allowing us to go our way undisturbed.

Manatees

By LATE JANUARY THE MANATEES have swum up the St. John's River to a warm spring in central Florida. A ring of such springs comes up from the vast Florida aquifer, rising at the edges of an uneven circle around the limestone beneath the land between Daytona and Gainesville. The place where the water comes up is called "the boil," as if the heat and rumble of the earth's core had forced it up against gravity. In fact, it's a very gentle motion, a quiet flowing movement, transparent water spreading out into a strong current, so clear that the algae living beneath it turn the whole stream a brilliant, glowing green, and the submerged manatees become great quiet green blimps until they rise slowly to the surface. Then their gray, leathery skins make apparent the patterning of sunlight on the water's surface, a wide net constantly in motion. The unruffled beast ruffles the surface briefly with its rudimentary snout, breathing and then sinking down into green again.

The manatees bear on their backs white scars from being hit by boat propellers, but at Blue Spring they are safe, lolling at leisure in the winter months, in pairs or groups or alone, sometimes making their lazy way up to the boil. They lie in groups near the long-nosed

alligator gar, the tiny minnows, the larger fish that glide or leap, briefly disturbing the surface with the flip of a triangular tail.

The park service warns visitors that there are swimming hazards here. That could mean alligators, but mostly seem to be dead tree limbs. The ends of these poke up here and there and are used by sunning turtles, or by an anhinga drying its tremendous black wings after a dive. They call the anhinga "water turkeys" because of their long necks and fan tails, or "piano birds" because of the way their spread wings open into an ebony keyboard, the sunlight playing over the oily feathers and the bird grooming the keys with its long yellow beak. These sights seem remarkable in the greenish glow off the flowing water, under the live oaks hung with Spanish moss—curtains of wildly successful epiphytes.

Surely such a stage-set for paradise was what the first American naturalist William Bartram saw when he explored Florida in 1765; in his *Travels* (1791) he described what is now Salt Spring as a sort of peaceable kingdom, the water and its animals moving joyfully together. "All peaceable and in what variety of gay colours and forms," he wrote of the fish, "continually ascending and descending, roving and figuring amongst one another, yet every tribe associating separately. . . ." In his description, the boil at Salt Spring—the *ebullition*, he calls it—is spectacular, even violent: "perpendicular upwards, from a vast ragged orifice," he says, a grand fountain, "astonishing and continual." In 1816 Samuel Taylor Coleridge transformed Bartram's verbal excitement into the domain of Kubla Khan, the unblemished water of central Florida becoming Alph the sacred river.

As it happens, the river does indeed flow through caverns measureless to man, down to a sunless sea, although man in scuba gear has of course not been slow to rise to the challenge of measurement. Current wisdom says the channel at Blue Spring goes 120 feet down. A diagram posted at the end of the boardwalk, just above the boil, shows the long chute beneath the surface and the bulging underwater cave partway down. Divers who've been in the cave report that in fact it's full of measurable material, tree limbs and railroad spikes. First-

timers and old-timers stand watching the boil; some of the old-timers remember playing freely in this place before the park service noticed there was something here that needed protection.

"You can go down there," one of them said, "and swim for miles through the underground passages. My son is a diver," he added. Briefly we imagine the sunless sea, the water without oxygen, inner space. We stand in the sunlight contemplating bravery in the dark, the urge to enter and explore the chambers of the sacred river, to bring back its secrets of darkness and debris.

Schoolchildren with their names printed on big tags stuck to their chests rush and push and stare down at the boil. A group of Japanese tourists speak at length to each other, pointing at the diagram. Their language is as mysterious to me as the manatees, as the Spanish moss. Back on the boardwalk a woman in a small motorized vehicle is trying to make a turn in the narrow space. *If you love me don't touch me*, warn the signs that show an apparently smiling manatee, slightly comical in a way the manatees are not in fact. Other signs urge us to look at the whole environment—the sabal palm, the wax myrtle, the fragile soil around the boil—and to care for it, in spite of our impulses to investigate and penetrate, to insert ourselves into unknowable nature.

We, too, are part of this world, and sitting on the dock staring down at a motionless manatee, my painted toes just under the crystal surface, I am aware of my fellow fauna roving and figuring amongst one another: a mother explaining to a nonverbal infant the miracle of the manatee, two old men vying to identify the fish, a small child crying angrily. An old lady says to the meditating manatee, "Go get some friends so we can see more of you."

Across the water a woman in a silver canoe marked "Manatee Research" floats under the trees, taking notes in a log, occasionally talking quietly into a small tape recorder. She has been there for hours, paddling in this placid world, keeper of the records. Many of the manatees are known personally by the park service, identified by the scars from the propeller wounds and given names. They are called Brutis, Lucille, Flash, No Tail, or Paddy Doyle. They are

not interchangeable presences in the water, but as particular as little Mackenzie and Kamali, Chelsi and Reid, Tyler and Mercedes, who have been brought here on a bus to see them, to learn about nature even as they are part of it.

This is not the world Bartram saw, not the world of the Timucuan Indians who once lived and fished here, whose relationship to the natural world in fact included eating manatees. The swamps of central Florida today run into slimy ditches beside roadways supporting little houses and small mortgage companies and short order restaurants. Now this beautiful spring is a refuge for us as well, not only because it looks like Eden, but because even though so often we cannot restrain ourselves from making a noisy mess, here we are relieved of our individual stupidity. We're all here for the same reason, and when we are looking at the boil or the slow animals, the light in the trees, the water birds and moving fish, we are drawn together, sharing the surprises of the earth, everybody equal.

We think that we prefer to be in Xanadu alone—and there are certainly springs where that is possible, springs where there are no manatees to lure a crowd. At Salt Spring today Bartram's ebullition is now a gently spreading pool, but still astonishing and continual as it surges to become a wide stream reflecting open sky, changing color as the sun lowers and lights the clouds. The water is just as warm, egrets pace the shore, fish leap. To be alone with the little blue heron and the trio of hawks making their way into the distance is one way to understand peace and the present moment.

At Blue Spring, though, in the company of fellow nature-seekers and holiday-makers we are also touching what is elemental in our lives. The anonymous throngs to whom the protective signage is directed are not extraneous to these beautiful places; they are part of the story of being here. They may seem to be what we would cut out in order to extract the sweetest parts of the experience, but truly in their details they are like the lively fish around the manatees, things we don't expect: the happy swimmer in a purple bathing suit ascending and descending in the current or the lady who said disapprovingly

you wouldn't get her in that water. ("'Gators," she snorted, having selected her preferred swimming hazard.) And when we just stand together looking at the vaguely moving creatures, we're here with a common purpose, as vague as they are, and as strangely present.

Indeed, we are stranger than they are, curious and wild in the way we run through the abundance of Florida, of our planet, giving the things around us names: manatee, sabal, boil, mortgage broker. We turn our encounters with what is not us into narrative. We are explainers, storytellers. We want excitement, causality, denouement. More. We are hoping, in fact, to see a 'gator in ferocious action. We want nature to come to the point, as we think we do ourselves.

In that spirit we have called these particular beasts *Sirenia*, an actual mammalian order that includes the equally portly dugong and the now-extinct Stellar sea cow. The family name is a joke we owe to Columbus, whose ship's log for January 9, 1493, noted, "On the previous day when the Admiral went to the Rio del Oro he saw three mermaids which rose well out of the sea. . . ." In keeping with the fact-finding nature of the expedition the note adds, "they were not as beautiful as they are painted though they have something of a human face." Today you can see a mermaid show at Florida's Weeki Watchee Springs, specially trained young women with pretty human faces wearing tight zippered tails, but they are always upstaged whenever a fat, whiskered manatee happens to swim into the viewing area with them. The siren song is still an unheard melody of inexplicable sweetness.

Like the Timucuan of central Florida, the Maya in Guatemala hunted and ate manatees, believing their meat increased a man's virility, and the earbone worn on a neck cord protected him from evil. These days, the story is about protecting the animal: without even leaving home you can adopt a living manatee, receiving for your financial contribution a certificate, a photo, and a biography of Elsie or Snooty or Dan.

The slow manatees, then, have drawn us into their story, and here at Blue Spring they show us ourselves in the speedboats that mark

them: Brutis, No Tail, Lenny, Deep Dent. We maim them and we name them. Still, they come to us, swimming up the river with their young. They come as if this were indeed a peaceable kingdom, and we only another species, sharing the warm winter harbor. They lie low down in the water; they come up for air. They have little hand-like fins on the fronts of their bodies. Sometimes they roll over. Watching them the mind digresses, slows, takes in the trees, the bright air, the minnows, the wrinkled necks of the old, the chirping of the young, the drifting canoe. In the company of noisy strangers, our diffuse tales about these creatures make bright patterns on the surface of the earth, then disappear as the green-tinted water pushes away from the boil: a liquid paradise we can almost join.

By the Pond

IT IS SUMMER AGAIN, and Avery very badly wants to catch a snake. There are some snakes near the house that are candidates for this possibility, but they are very quick and move by an instinct for self-preservation that has proven to be a very powerful counterforce to his desire. Avery stalks his prey in the field by the house, his figure small in the foreground; beyond are the trees, then the distant lake and mountains under faraway clouds. Once there was a snake on the step by the back door. As usual, it was quicker than he was.

Now we are on a long walk around a hidden mountain pond. Avery's brother is desperate to swim. He keeps finding just the right place to get into the water but his desire, too, is thwarted, in this case by the grownups, who are skeptical about the water temperature. In the middle of an argument beside a large uprooted tree stump, a long snake moves slowly under a broken branch.

One of the grownups briefly had a snake of his own when he was a child, and so has both understanding and a speedy foot, which he uses to pin the snake. The animal writhes in protest as the man manages to get a grip on it behind the head. The family group watches the snake struggling to avoid the encounter. Then it

is lifted into view, the tongue red, forked, darting in and out, the body paradoxically coiling around the very arm responsible for this unwanted captivity.

Avery's father photographs the interaction: the wrist and arm encircled by lizardskin watchband and live snake body; the small head and bright tongue; Avery's excited face. He wants to hold the snake himself, but the transfer is impossible. For one thing, while this is not a poisonous snake it does have in its arsenal of defense a nasty smell arousing a general eagerness to put it down. Others in the party are also wanting to move on, a snake not being central to the nature experience the rest of them are enjoying.

The big snake disappears and Avery is distracted from his disappointment by two smaller snakes sunning themselves on the other side of the upturned stump. They are two bunched knots, and then they move toward each other. Their motion is so smooth and fine, almost a shudder, that when they do touch stillness and motion seem to be the same thing. They are unaware of observation by the little knot of people with their varying feelings about encounters with snakes. Their world seems to be the sun on their scales and the sliding of body along body, small heads in opposite directions. I know nothing of the snake brain.

Everyone moves on, the dog running ahead. The pond is clear and round. The trees come right down to the shore. Avery does not move on. He is deaf to his mother's cheerful voice calling to him. He sits on a rock across from the two little snakes, staring at them. Wanting them. The sun picks out the down that covers the back of his neck where his sweatshirt falls away. He sits as still as the two snakes. He wants to hold one of them and have its body wrap around his arm. He is not leaving.

I touch his warm and fragile shoulder and try to explain that there are other ways of relating to animals, that the two snakes are having their own relationship with each other and that we are lucky just to see it and do not need to intervene. This is a ridiculous story.

What I mean when I say *relationship* has nothing whatsoever to do with the mysterious creatures now part of that uprooted and earth-covered tree stump, that flexible pattern of light and shade, crumbling soil, and barely conscious eye.

"Avery, I think there's a fox hole here," calls his father, coming back along the path. Avery is as still as the snakes. He does not have a relationship with fox holes or with those who are interested in them. His enormous desire stops time and separates him from the rest of us and from our pathetic tales about what we are seeing when we walk in the woods. I murmur to him that if he cannot have the snake wrap around his arm, if he cannot make the snake part of his physical experience, he still has his powerful human brain; I say that he can possess these snakes always in his memory.

"I'll forget them," he says, not petulantly, but with finality.

I lamely suggest that what we are seeing might be a subject for art, that he could draw them, so as to remember them. I am of course edging toward this moment when I will try to describe them myself. I do not wish to touch them, only to mark their strangeness with a verbal transformation. Now he says if he drew them he would lose the drawing. If he wrote about them, he would lose his notes. Furthermore, he is uninterested in the granola bar his father is now offering, or in the relationship we two adults are having around the granola bars and the problem of a child who wants to hold a snake.

The sun glints on the water and Avery sees a loon's swift dive into it. He picks up a dead branch and waves it toward the two snakes. His father strips off the smaller twigs until it is just a stick, so Avery can reach across the intervening brush and touch reptile skin. One snake slips further along the other. Avery pokes again. In an instant one snake is gone; then in a motion so fast our eyes can't register it the other snake has become part of the dense interior of the upended stump. Vanished, into the brain of the forest floor, which has already lost its memory of us, of Avery, with his quick eyes and unwavering longing for physical connection with the interior of life, of life without

metaphor or art or memory or the eagerness of dogs and the fickleness of human categories. For the loop of snake body around bony child arm, for the glitter of water in a hidden pond.

Oxherding
in the Chisos Mountains

ALTHOUGH WELL INTO HER SIXTIES, Karen made it up and down Lost Mine Trail in two hours. She was training for a trip to Tibet, and her point here was about strength and endurance. The following year her account of the Tibetan trek was indeed a story of impressive physical and touristic challenge: vertical mileage, unsavory waste disposal, prayer flags in the thin air. Crowds of pilgrims from far away continents improving their karmic situations. Lost Mine was small potatoes, far in the past.

On the other hand, small potatoes are very tasty, don't require a lot of preparation, and you can eat them at your leisure. When we climbed that trail ourselves, for instance, we met an old man less than halfway up who was just sitting on a bench and looking into the spectacular distance of Juniper Canyon. His group of fellow elders had trooped onward but he saw no point to that. He was old, and he thought that the time he had left would be better spent staring into the morning light on the mysterious deep and spreading canyon, the mist-veiled vista of the present moment, than in stumbling on, staring at the stones on the path (as he said), toward a higher spot above the same moment. Only by then the moment would be past.

Karen said that the two hours included taking time to read the self-guiding interpretive pamphlet, with its news about different kinds of oak trees (Gray, Emory, Chisos), the Mexican drooping juniper, the skunkbush sumac, which is related to poison ivy but not poisonous itself. The multiple uses of the lechuguilla plant for birds, for deer, for prehistoric Indians and for Mexicans today. "This plant," it says, "is very important where stores are far away." They are very far away here, and of course were in Tibet as well where, as Karen has now written, the Sherpas carry and prepare the food.

We are carrying our own lunch, however, and we are not going to Tibet, and so continue upward at our own pace, eyes on the stony trail, but remembering to look at Juniper Canyon and also in the other direction, toward Panther Pass, where you can see the vegetation change abruptly from pinyon and juniper to ocotillo and lechuguilla because the climate on the north side is different from on the south side of the pass. We too are following the interpretive guide, you see. Karen's trip to Tibet took her across a river with a frozen waterfall, and up to a pass more than 18,000 feet high. At the end of the trail we will be only 1,000 feet higher than when we started and this is not even the highest you can get above sea level in these Chisos Mountains of west Texas; still, it is high enough to see the sky and get perfectly lost in space, as it turns out. Karen saw rams' heads hanging on an altar, elephant tusks, and a yak caravan; but I am thinking of the Ox.

In twelfth century China, or at least in the *Oxherding Pictures* by the poet Kakuan, the Ox was a symbol of Buddha-mind, and in the first one the Ox is missing or at any rate seems to be. Losing your Buddha mind seems to be a lot like losing your regular mind, which you could say was exactly my state at the beginning of this hike. Everything is anxious and tense. Is this the right hike? Will that busload of elders ruin everything? Can we park here? Will we be attacked by a mountain lion? Is the self-guiding pamphlet too silly? Will I be too hot or too cold? Am I now too hot or too cold? Greed for worldly gain and dread of loss spring up like searing flames, ideas of right and wrong dart out like arrows, as Kakuan's images describe this state.

As we are adjusting our boots, the elders disappear ahead of us,

in their wide-brimmed hats and fanny packs. We stop to read about how to behave in the presence of a mountain lion and to learn about the different kinds of oaks. Then we are alone on the trail, winding upward past the canyon called Green Gulch, and into the mountains proper. It's still early, still chilly. We learn that the ash tree is in the olive family, that in a couple of months it will have sweet-smelling flowers. Even without the flowers, though, this is a pretty good hike; possibly I am catching a glimpse of the Ox, or at least seeing the tracks, greed and dread subsiding.

Now, even though a man in a bright yellow jacket occasionally mars the view ahead we mostly only notice the vegetable rustlings. Kakuan says even the deepest gorges of the topmost mountain can't hide the Ox's nose which reaches right to heaven, and sure enough, when we get to Juniper Canyon there it is: an immense rock called Casa Grande. The deepest gorges of the canyon are shades of green and full of vapor, form and emptiness at the same time. Plus a couple of stray butterflies drifting up on the warm air from Mexico, from the Rio Grande miles and miles away. Mexico and Texas become meaningless X-shaped words and I think this is a first glimpse of the Ox, this quiet green distance, these eons of space. That splendid head, those stately horns, what artist could portray them? asks Kakuan, even though the man in the bright yellow jacket is trying to take a photograph.

We have our camera with us, too, and later, when we stop to pull out of our knapsack an apple, walnuts, sunblock, we snap each other under a scrubby unidentified tree at the edge of another view. Further on still, we meet the group of elders on their way down. Soon we too will be elders, so we take note of the future, its good cheer despite signs of personal aesthetic collapse and pink knit garments. They move past us in a flood of peppy remarks about what lies ahead on the trail. Then a young woman with a swinging water bottle stops to corroborate this good news. She had passed us earlier on her way up, moving fast, like Karen, in her well-trained body. Maybe she too wants to walk on the roof of the world, to rise in the dark, sit among prayer flags and white scarves, to be forgiven her sins, and reborn. Oxherding, oxherding, we are not in a hurry; we are not young, or old, or ambitious.

Once this whole park was a vast inland sea, but that was in geolog-
ical time, which in our case we have not got. Millions of years of com-
pacted silt and sand and seashells, and also molten rock and lava erupting
to the surface. Rocks of terrifying size. Now, royal sage, evergreen sumac,
Texas madrone, mountain mahogany (confusingly, a member of the rose
family), and crusts of lichen. The lichen are busy making soil from this
tremendous rock. The geological patience all around us is remarkable.

Then we are at the top. Directly across the canyon is Lost Mine
Peak, and when the sun hits it just right and you are standing in just the
right place you can supposedly see where was the entrance to the riches
of the mine, now lost forever, as the name reports. Fortunately, gain
and loss no longer affect us. We are alone up here; below, on both sides,
the terrifying, indifferent canyons, the air. We eat our lunch, provisions
from a supermarket deli somewhere in the geological past, before we
saw this. There is no one here to offer us yak butter tea, no one chant-
ing or playing drums. In the sky the clouds drift and change. They are
perfectly imperfect, permanently impermanent. They move and scatter
and regroup and sift through the blue. The sun catches one edge. My
head does not turn in the direction of temptations. This Ox requires not
a blade of grass. It vanishes like the cloud I was watching a moment
ago, broken into another shape. Self forgotten. The sun catches the
edges of me, burning my neck and arms. Ox forgotten. I am wrapped
in the twelfth century; I am free in geological time.

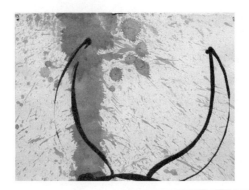

IV.
Particular Artifice

Boxes in Texas

A BUSLOAD OF HIGH SCHOOL STUDENTS from San Angelo has come to see the art at the Chinati Foundation, on the high western Texas plateau. I am here, too, wandering through the artwork called "School Number Six" that Ilya Kabakov has created out of an abandoned U.S. Army barracks. I have read that Kabakov doesn't do site-specific work, that he creates his own total installations, complete environments that invite the viewer into a narrative world entirely of his making. This one, however, seems particularly suited to its site. The old barracks, with its long rooms and straight rows of windows and atmosphere of dank ruin seems as much inspiration as incident for this three-dimensional tale of Stalinist childhood. Both barracks and school testify to vanished culture and belief. The barracks was part of an American cavalry base, a training ground for wars whose remaining soldiers are all past eighty, and whose horses are all dead. Kabakov's imagined school was a training ground for a great dream about the future of all mankind, now as dead as the horses, collapsed under the saddle of its own ideology.

In the rubble of the military quarters, the artist has reconstructed the rubble of another time and place. The Texan students cruise among the broken benches, the piles of trash and dirt, peering into

the wooden display cases and forlorn cabinets. They are interested to be in this model, this mock-up, this unmistakable if seriously run-down educational venue. A group of girls registers disgust at a bug collection Kabakov's fictional Soviet children have put together. An acne-faced boy is caught by a case of old glass chemistry equipment. "Cool," he says, although I can't tell if what's cool is its familiarity or its antiquity. A larger group gathers in a small room at the end of the building where a lute-like instrument is hanging on one wall. They seem to be transfixed by a case with a flute and a trumpet inside, along with a piece of sheet music purporting to be a third grader's original composition called "Dawn in the Forest." More students drift in and cluster—all the band people, it turns out, drawn to these relics of imaginary musical instruction.

Then they are gone and I am alone again in the scattered detritus of education: photos of heroic workers and Young Pioneers, a map of Moscow, ripped illustrations from fairy tales, a pictorial dictionary, a guitar with a missing string, a sports trophy, a page of spelling exercises, an empty little paper bag, printed cards of incidents in the life of Lenin. On a blackboard propped between two tables an elephant, a goat, and a horse are drawn in chalk. It all seems so casual that I start to sit down at a desk, but the bench is covered with mouse turds. Is this part of the art or an intervention by the local fauna?

In the almost empty western wing of the barracks the sun makes fourteen bright rectangles on the bare floor. Two women are cleaning the glass tops of the spindly-legged display cases. I ask them how they know what to clean and what to leave. They have been trained to leave the accumulating dust, they say, and then volunteer that several of the doors leading into the scraggly overgrown courtyard were only recently put in so as to discourage bats that had taken up residence. There used to be lots more debris, they add. The installation and the site have been growing into one another.

The display cases, indeed all the furnishings, seem scattered at random, as if once swirled in a great flood and left where they landed. The artifacts they hold, labeled in Cyrillic and English, provide an expanding narrative of child life in the school: a list of Rules and

Responsibilities for the first graders; a set of Instructions for Keeping the Journal; the scissors of a girl who was talented at needlework; the top of the paint can from the day the students painted the desks; an old pan found when they were digging holes for the school fence. Just as carefully labeled is a bit of crumpled paper the students liked to play with (confiscated by the Pioneer leader). Beside it, a more melodramatic artifact: the empty box of matches presented to the school by a pilot, who had used the last match to light a fire so as to be rescued after being shot down. Shot down, that would be, in the same war once supported by the eroding barracks.

Broken benches, empty picture frames, ripped flags, waterstained papers, a dirty rag one child used to wipe his desk, then threw to the others at recess—so many documents of absence. Empty and crumbling window frames open out to the Texas sky; prickly pear grows in the sun-filled courtyard—and those metal chimneys protruding from the roof, were they from stoves warming soldiers or children? The US Army's Fort Russell has become a destination art attraction, and Kabakov's memoir of high spirits and indoctrination and friendship and deprivation and learning and deformation is sited now in a landscape of dry grass and spreading sky, within the architecture of bygone military preparation.

Ilya Kabakov was born in 1933, and did not leave the Soviet Union until he was past fifty. Within the structures of official control he was both a legally sanctioned children's book illustrator and part of a dissident art movement in Moscow. He lived a double life of obedience and distrust, of lonely longing for the great river of art (by which he meant international art) on whose banks he felt marooned, and the communal excitement of underground (and officially invisible) creativity. At the Leningrad Art School, the artist told an American museum director, "I was like a trained monkey or dog. The person inside me didn't have any contact with my hands, with what was produced by these hands."

Later, as he made his living drawing elephants and trains and balloons for children's books, his internal world fed on the boring, banal, discarded aspects of everyday life—bus tickets, dirty bottles,

advertising. The connection between art and garbage—the dustbin where unsanctioned work could so easily end up—became more and more interesting to him. By the time he finally left the Soviet Union, that connection was his reality, which did not change. The great theme of Soviet civilization was like a tank of fuel to be burned, he said.

Now he invites the viewer into this three-dimensional—or rather, four-dimensional—space where the fragmented stories and the absent children dramatize the split in his own story, his own exile. Here are banality and decay, discredited heroic realism, and also art and knowledge. Everything decays, says the school: the smiling faces of the Young Pioneers, the kitchy painting of the noble girl in a field of flowers. Labels carefully written in Cyrillic, with typed English translations, explain How We Repair Our School, and (under faded postcards from the Visit to the Historical Museum) how two boys named Kozlov and Anikeev started a duel with pencils and almost turned over a showcase in the room commemorating The Victory of the Russian Army. All of this is now debris—the minglings of artifact, fiction, and memory, the labels and translations; they mock not only the world displayed, but the very idea of display itself.

Indeed, Ostrovsky's illustrations for Snow White are fading, yet all this is vivid, intense, certainly more present to me than the high school in San Angelo, or the one I went to myself. It's an illustration now alive because I am able to walk right into its trashed world, to notice the mouse turds, linger over the story about the misbehavior in the museum, imagine the musical and scientific accomplishments, to find myself bemused by the mingling of child labor with practical instruction in institutional upkeep. Kabakov's lifelong attention to the rubbish and dullness of everyday life has brought his own past into the future, into my present, and along with it the dead dream of historical transformation. The artist's long affection for his impossible past gives the Soviet garbage—this defeat of hope, this foolishness— a tragicomic presence in the enormous light of today.

Outside the fence at the open end of the courtyard the wind blows through the yellowed grasses; pickup trucks run along the

county road toward the Mexican border. Six other barracks identical to this one have been treated quite differently, painted a clean white, their ranks of windows sealed over and bright neon light sculptures by Dan Flavin installed. Long empty rooms with long brilliant views out the one small, mullioned window left unpainted at one end. At the other end are cubes of green or rosy light created by bars of tubing, cages of contrasting color: pink and green, yellow and blue. Color and light are the same here, a single phenomenon creating the geometric shape of the space they touch. Sometimes at night the young Chinati interns turn them on and go out into the fields with a six-pack to watch them shine mysteriously into the blackness under the stars. Like Kozlov and Anikeev in the room of the Victory of the Russian Army, they are paying their slightly transgressive respects to those who have gone before them.

The Chinati Foundation, too, is a grand dream for mankind, for the possibility of making something that is true. *Most art is fragile and some should be placed and never moved again*, said Donald Judd, who (with the help of the Dia Art Foundation) bought the crumbling cavalry base in the 1970s as a place to create permanent installations for contemporary art. What was interesting in contemporary art, he wrote in 1965, was "the thing as a whole, its quality as a whole"—complex purposes asserted by one form. "Actual space," he himself asserted, "is intrinsically more powerful and specific than paint on a flat surface." Judd lived at that time in New York City, whose great art institutions he found unresponsive to artists' true concerns, to the art of his time. "The museums are monuments to the rich," he complained in *Arts* magazine in 1973. "As a monument the building is crucial and not the contents." He was also irate at the way most museums handled artworks: at the carelessness of truckers and guards, at broken welds and surfaces disfigured by warehouse stickers and sticky hands. At the conditions available for looking at art: "No space, no privacy, no sitting or lying down, no drinking or eating, no thinking, no living."

And so he brought art to the high desert, to this place of space and light, to a desert town of wide streets and yucca plants and cawing

ravens and affordable real estate. "Somewhere," he said, "just as the platinum-iridium meter guarantees the tape measure, a strict measure must exist for the art of this time and place." This is the first I have heard of the platinum-iridium meter, but I can see how the tape measure, or at least the idea of strict measurement, would be on Judd's mind. A truth of perfectly fitted materials underlies the beauty of his work, both here and elsewhere.

Take the spectacular example of the one hundred milled aluminum boxes installed in two former artillery sheds. In their original guise these enormous garages must have been very gloomy places full of war machinery. At one point they were also used to house German prisoners of war. Now they are tremendous light-boxes, all the doors removed and replaced with glass: eighteen floor-to-ceiling panels divided into four quarters by giant crosses. Inside, the aluminum boxes draw the eye down their three long rows in a heady demonstration of perspective and solidity and geometrical space. They are all the same size, but each configured slightly differently: open on the top, or on the side, or on two sides, or divided by a diagonal panel or a horizontal one or a vertical one. The aluminum glows in the shifting light, or seems to be transparent in the way it reflects it—sometimes the metal boxes appear to be plexiglass. Complex purposes asserted by one form.

Sitting on the floor in a square of sunlight at one end of the building I can see someone walking at the other end and also—disorientingly—reflected on the side of a box that is very far from where he actually is. Then he disappears. Not a speck of trash here; each box precisely placed in relation to every other one and to the grid of cement blocks that make up the floor and the square pillars that hold up the grid of the ceiling. Foursquare tribute in every direction to the platinum-iridium meter. And yet the space is full of movement; the wind and light outside are a quiet presence in a continuing narrative of relationship in which nothing is ever lost because (like that person at the other end of the room) it's always changing, always in transition. Everything takes its shape and its expression from everything

else, and the stripped simplicity—Judd's so-called Minimalism—
just makes that easier to see. No illusion, no representation: the use
of three dimensions, he said about art that is neither painting nor
sculpture, opens to anything. Actual space, powerful and specific;
the obduracy and density of materials. Here, at last, minimal can be
seen as maximal—so big in conception and execution, in scope and
effect, it's as if there were no vanishing point along the parallel lines.
It seems to be entirely about the present, about being here now, not
about a lost civilization or shattered dream or interrupted story.

There are, however, the remains of the old brick walls at either
end, and on the one leading to a small anteroom by the entrance are
stenciled two warnings: *Den Kopf benutzen ist besser als ihn verlehren* and
Zutritt fuer unbefugte verboten. The first turns into ominous German the
jaunty American hint: Better to use your head than to lose it. The sec-
ond is less roundabout; it means Posted, or Keep Out. (The idiom lit-
erally means "admittance is forbidden to meddlers," which in the case
of prisoners of war seems remarkably circumspect.) So, there's some
history here too, a relationship to past presences as well as to optical
and geometrical principles. As it happens, Judd himself was posted
to Fort Russell during World War II. Here, like Ilya Kabakov, he too
is burning the fuel of his past, retelling his own story in a language
of art, inviting me into it, making me part of it. Here, if you make a
flute of your folded hands, the note you play will ring out through the
building, resonating with the metal boxes, and turning into sound the
relationship this lovely installation has with transient you as you pass
into and through it.

Judd, suddenly dead of cancer in 1994, did not stop with this
narrative of form and space and purpose, in its great glass-sided case.
Visible out the windows on the east side are what appear at first to
be pieces of an old construction project in the field below. Scattered
onto the particular land that covers the planet in this place—tracts
that were here before the army came, before there was a Soviet Union
to the east or a Mexican border to the south, or even any east or
south for that matter—is a series of immense concrete boxes, great

blocks arranged in different configurations along a wide sweep parallel to the barracks. Strictly measured and poured, assembled and sited: two-and-a-half-by-two-and-a-half-by-five-meters each, with one end open, like a cave, or with two ends open, framing the landscape. The sun gives itself to their shapes, using their angularity to make its own diagonals on their sides, sliding into rectilinear moves that give the heavy blocks a lightness, an uncanny, impossible transparency. In a high wind, being among them is like being on a ship, in a harmony of wild elements and orderly construction.

Grouped in fours or threes or twos, or lined up in a row, the boxes put the blowing grasses, the prickly pear, the bare, spiny plants and the spiky trees, the lone bird flying from a low bush . . . they put all of these into focus, give them a place in the narrative of looking; they frame the line of trees along the highway, or just two trees with a blue tractor between them in the distance. When Kabakov came to the West he rejected its white cube exhibition spaces—his dream of the river of international art did not include its alien conventions for display. *Some art should be placed and never moved again.* Here at Chinati, Kabakov's expansive mess of memory and trash and culture, like Dan Flavin's clean and colorful, sixfold appropriation of mass-produced industrial lighting, has reformulated the experience of visiting art. Judd as well has broken out of an unlivable context; the cube itself is the thing displayed, now pulled into conversation with the wide-openness of everything around it. *The use of three dimensions opens to anything.*

In places of shelter among these box temples the sun is warm; grasses have begun to grow in the joins of the great slabs; a praying mantis cocoon waits out the season in one high corner. I had been alone among them for an hour, and yet it hardly seemed surprising to encounter halfway up the row another person, a man with a stubbly gray beard, with wispy hair flying in the brisk wind, his turned-up jacket collar a feeble protection on this ocean of high wind and winter sun. Only days later did I learn that this had been an old friend and benefactor of Judd's, visiting briefly from Houston. He spoke to me

in a German accent of the American lack of roots and Judd's efforts here to overcome that; of the need to spend enough time with art so the art can look back at you. The sky was full of cirrus brushstrokes—powerful and specific—and we walked together to the last box, and then up out of the field, where we parted, into our separate stories.

Inventing Cinema

WHEN THE MOVING IMAGE *came into being, it seemed as if it could run time backward and forward, repeating and remembering. The lens catches a momentary image; then—like song—it scatters the moments into the future. In fact, though, the past became quite different from us, a series of lost gestures. The moving frames carry us further and further away from their images.*

Even so, to watch a film is to become part of its invention, part of its time. It pulls you into its system; it trains you. It shows you what you want; it stops your time and brings you into a place where even though it's the last minute there is always enough time. When the lights come up, when it's over, it stays with you like your own dreams.

And still, the pleasure is always the pleasure of movement. We see ourselves in the throwaway gestures and unsorted specifics, moving through our lives as the spool advances. We're set free to follow desire, to see what we didn't know we loved. The images that move and draw us into them and out of the clay of our own bodies remind us that we, too, are creatures of light.

Baby's Lunch

The afternoon is beautifully composed in a garden somewhere in France. A table is set with cups and plates and a small tray with a coffee pot, but the most important place belongs to Baby, sitting in

a high-chair between his parents, commanding all their attention. It is 1895, and they are feeding the baby, who takes the food into his mouth with pleasure and ingenuity. This goes on for thirty seconds, which is rather a long time to be watching such a scene through the unwavering eye of a fixed camera. There's plenty of time for baby to get the food on his chin and to enjoy a bit of a square biscuit. The wind comes up, fluttering the elaborate layers of baby's collar, and blowing a napkin across the table. In the background the trees ruffle their leaves.

Thirty seconds would not of course seem a long time were this a painting, the kind of painting this composition with the well-provisioned table in the foreground and the family lined up for our inspection in fact resembles. If this were a painted portrait—*La famille Lumière*, for example, lunching outside Lyon in the late afternoon light of the nineteenth century—it would easily sustain a gaze of several minutes, the trees seeming to flicker in the vanished light, the parents' faces smiling (or not), the baby's clean and sweet. It would be a post-Impressionist moment remembering the lovely days of looking in full daylight, breaking that light into color, the family an orderly bourgeoisie in the gentlest of natural settings, a canvas marked with dried paint, a lost world framed in carved and gilded wood so as to mark the break between it and the wall, reality, now.

Instead, it's a comical and messy event: the spoonfuls that miss their mark, gustatory anxiety, parental distraction, because the unblinking machine is running, the film continuous frame after frame catching every smile and gesture; and simultaneously time is running out. These Lumière cousins or in-laws, the light-filled scene, simply disappear, leaving us wondering what happens next. We are left midmeal as time hurries on, the film runs out. This bit of celluloid, composed with the corner of that solid white house behind it, this slightly shaky medium shot of generational happiness, this brief sequence of feeding the future, is all that's left of that moment.

Decades later shots rove easily from classroom to street to backstairs, from close up to high crane, tilting, cutting to an amusement

park ride where the camera goes inside the whirling zoetrope to watch the still faces of the onlookers rush into motion. Truffaut's hungry runaway boy steals a bottle of milk and drinks it in the dawn streets of the beautiful December city, steals a typewriter, spends a night in jail, and is sent off to be reformed in a detention center near the sea, which he's never seen. But he slips under the fence: running and running, the camera unblinking and running with him as he breathes and runs toward the open water, the winter sand, his feet in the low surf, the

camera waiting, tracking steadily, always running, as he turns at the edge of the land and faces its lens, and suddenly the world of motion drops back to the stillness of a framed event, the stillness of the past. The film doesn't run out: the projector throws onto the screen, frame after frame, the same image, stopping time, arresting our gaze and the afternoon wind ruffling up his hair.

Crosscutting

The beautiful teenage Gish sisters show up in the Bronx on a summer morning in 1912 looking for their friend Gladys Smith who is working at the Biograph film studio. They want to be actresses on the stage, but they are currently between engagements. Gladys is actually a successful actress herself, and she has been renamed Mary Pickford

by the theater impresario David Belasco, but she's been slumming
very successfully in the movies for three years and she is delighted to
see the Gish girls and their mother (with them, of course). She intro-
duces them to her director, D.W. Griffith, who enters this scene sing-
ing *La ci darem* . . . a fragment from a Mozart opera. Biograph has
built a new studio that even though it is in New York City is won-
derfully lit by both natural and artificial light, but Lillian Gish, he
notices, seems to have a luminous glow around her that did not come
from the skylight. Furthermore he thinks she and her sister sitting
together on a bench are as pretty a picture as he's ever seen and, being
a dealer in such pretty pictures, he takes them upstairs for a screen
test in which they are terrified by burglars and Griffith fires off a
revolver he happened to have in his pocket. Their fright is convincing,
and the next day they become the stars of a one-reeler.

Close up: a tin plate covering an empty stovepipe hole is slowly
pushed away, and from the darkness the nose of a handgun pokes
toward the audience. Medium shot: the beautiful teenage Gish sisters
cower in a corner of the room, their matching striped dresses and soft,
light-filled hair making them appear each other's doubles. Innocence
is horribly threatened because in the next room an untidy female
family retainer (The Slattern Maid, according to the inter-title) has
arranged for an old friend to blow up the safe in which the girls' slen-
der inheritance from their recently dead father is stored. In a moment,
though, one of them will grope her way to the primitive telephone
and call her brother, who has gone off to work, on his bicycle.

The Slattern Maid has been enjoying the adventure, and has
been refreshing herself with a handy pint of hooch, so as the brother
is hearing the plea for help he also hears the exuberant gun go off.
Crosscutting: the puff of smoke from the gun; close up of the broth-
er's face contorting with horror. He has a small mustache and is still
wearing his derby hat. Electrified, he leaves his modest bike leaning
against the outside wall of his office and commandeers a motorcar.
With him now, equally alarmed, are: a coworker, the chauffeur, and

the owner of the car (who rushed into the frame as the commandeering was occurring).

Long shot: the men, hanging on to their hats in the open coupe, race along the country road. Cut: the girls in their lovely fear are clutching their angelic faces. Time elongates: the car races onto a drawbridge just as it's slowly turning to cut off the route. The four men leap from the car, gesticulate at the bridge keepers.

Back at the house the safecracker produces clouds of billowing smoke. The crosscutting seems like real life, better than real life, here and there happening at the same time. We are seeing the sorry truth of crime even in the simple lives of two orphaned girls and also the heroic speed of the American automobile. The Slattern Maid, her arm thrust through the stove hole up to the shoulder, gleefully waggles the weapon in her hand. *La ci darem la mano, la mi dirai di si. . . .* Ah just give me your sweet hand. We are caught in the rhythm of rescue and the rhythm of morality, and the rhythm of seduction. *Ah fuggi il traditor*—the flight from evil is accomplished; Don Giovanni's song is no less sweet when enfolded into a happy ending.

Montage

The troops cast their advancing shadows on the steps: the threat itself is unseen. Silent scream; the baby carriage rolls. It's 1925 and the story is montage, beautiful propaganda. Before the triumphant ending come the broken glasses, the broken child. Cossacks emerge from the evil past, the crowd flees, a massacre that never happened becomes history. Mr. Goldwyn is impressed: Please tell Mr. Eisenstein we would like him to do something of the same kind, cheaper, for Ronald Colman, who is under contract to the Goldwyn studio. We wouldn't have to go to Odessa to shoot; we can build anything right here.

Montage: the uniting of shots of seemingly unrelated objects in the same film sequence so they take on a new relationship to each other. A series of visual explosions like an internal combustion engine driving forward its automobile or tractor. A grand experiment with the agility of the human brain, like hieroglyphs, said Eisenstein: knife + heart = *sorrow*; dog + mouth (whose mouth?) = *bark*; water (a pool? a drop?) + eye = *weeping*. Montage: bits of film joined surprisingly, to create new meaning, to analyze a historical moment. The grand experiment of Mr. Goldwyn would put Ronald Colman on the battleship Potemkin, indeed shocking the spectator's mind into motion.

Later (1941): You provide the prose poems, I'll provide the war, says the newspaper tycoon. The war was entertainment, leggy girls in Rough Rider hats, their dancing reflected in a dark window. This story's montage unfolds differently: a boy taken from his home in the west, the snow falling and falling; the years pass and the newspaperman tweaks the banker, buys up the opposition with the speed of a flashbulb popping.

Politician moving in a deep focus dream space, patron of the opera clapping into slow dissolves; then multiple doorways stretching into a broken future, multiple selves projected into the mirrors, multiple

stories going up in smoke. No Trespassing, The End: bright empty screen in a shadow space, the outlines of a life blank, dark, gone.

Montage: giant lips pronounce one word, the distorted doorway through the broken glass of the snow globe, the drifting snow. Kane dies alone. The little sled is thrown on the fire; smoke rises behind the iron fence. The camera backs away from death and stillness. Keep out, keep out. The long take: one life.

Melodrama

The stuntman throws himself forward over the galloping horses; their hooves pass inches from his body. He retrieves the reins. On the roof of the stagecoach John Wayne fires at the onrushing Apaches. Inside the lady from Virginia is praying; the elegant gambler plans to shoot her with his last bullet so as to save her from captivity. The pursuing Indians are a force of nature, a dense primeval forest, a ridge of snow-deep peaks, a violent storm beating back territorial expansion.

Actually, they are Navaho living in Monument Valley and hired by John Ford. Geronimo masses his braves on the bluff. When the cavalry arrives, the bugle blows, the Navaho wheel their horses away and break for lunch. Later, the gallant gambler dies; manhood passes definitively to the brave and beautiful face of John Wayne, the Ringo Kid, who has privately saved three bullets for the three foolish men in black hats who killed his brother.

Time passes. The West is won. Bravery takes on a different face. Jimmy Stewart (young, slender, stoned on Abraham Lincoln) is appointed Senator by crooks without guns. He brings the strains of western song to the soundtrack of filibuster, the great marble mise-en-scène of Washington, D.C. The goodhearted alcoholic doctor on the stagecoach (Thomas Mitchell) is now the goodhearted alcoholic political reporter (also Thomas Mitchell).

Mr. Smith fumbles his hat in the presence of a pretty lady, embarrassing himself like Joe Gargery in *Great Expectations* when he comes to visit Pip in London. (Griffith, defending crosscutting: "Isn't that

what Dickens does?") Later he is carried off screen in a dead faint, as a gunshot in the cloakroom finally signals his victory. Corruption collapses in an orgy of newsmen freed to broadcast the Truth. The weary Senators turn like well-paid Indians to vote against graft.

One bullet is always enough when a man comes out of the West to do what a man's got to do. Comedy rides in at the last minute, and gratefully the woman (Claire Trevor, Jean Arthur) gives up her questionable ways and gives him her hand. The prairie grasses bend in the wind as it sweeps east from the mesas in the nick of time.

Expressionism

It starts with the zither. Then there's ruined Vienna, beautiful montage of a city—rubble and statuary, angels and putti and important figures from the past, wet cobblestones and earthworks, and finally rushing waters below the streets, the graveyard, the long avenue of trees. The woman walks and walks and walks and leaves the frame without looking at us or the man waiting; unforgiving, her hat steady, she is faithful to Harry Lime, now lying under the final spoonfuls of earth.

Harry Lime was really Orson Welles, and we'd been waiting for him through half the movie in a world moving seductively from canted close up to urban vertigo, from street portrait to cityscape to the glittering fur on the little dachshund, from the eerie child with the rubber ball to the winged coifs of the sisters in the children's hospital. When Harry Lime first looks at us, his face is suddenly lit in a tour de force of camera play, of light and darkness and nighttime surprise, and zither crescendo.

The screenwriter: on location in the postwar winter, at the Sacher Hotel and the Mozart Cafe, long evenings of solitary drinking at the Oriental nightclub. He finds the balloon man, the ferris wheel, Harry's indigestion, the joke about the cuckoo clock, the powerful and incomprehensible German language, four powers splitting and occupying the city. The director asks Welles to run through the

sewers, but he's from California and doesn't like the cold. Shadows and arc lights, then the director himself, Carol Reed, puts his own hands up through the iron vents to the street, a crown of fingers, loose and desperate under the camera's eye.

Footsteps and white puffs of breath in the December air. Bomb craters and a broken empire, black market watches and shoes and cigarettes and diluted, deadly penicillin. The deep happiness of darkness and lively zither strings. Who'd see a movie called *The Third Man?* asked David O. Selznick; why not *Vienna at Night,* a title that'll bring them in?

Acting

The city has been rebuilt but ash is still falling. Do you remember the daring of that moment fourteen years ago? A second sun dropped on the city, giving the four simple syllables of its name an intensity that is now to be reimaged in the passion of two lovers.

The actors arrive on a day so hot their clothing sticks to their skin. The beautiful Japanese hero has to learn his lines phonetically—he does not know French. The beautiful French actress who was not yet a star becomes the woman who says yes and then no, torn by memory and forgetting. She is playing a movie star; in the morning she dresses for her role, covers her shining hair.

In the story we are watching her hair is important—clipped off and her young life draining away in a cellar bedroom, on the wartime banks of the Loire river. But it grew back and it's prettier now, pushed back from her face by the Japanese lover, or swinging across it as she tells her story.

The actress' face was discovered by the director in a pile of photographs, and now she abandons herself to the other body of the character, to a past in the provincial city of Nevers and the present in famous Hiroshima, which is in fact the present in famous Hiroshima. Hiroshima is a museum of atrocity, with angular new buildings and a parade of belated demonstrators for peace. What a story! What a

series of images to be seen and understood and appropriated! Did you see anything in the city or not? Or on the screen? Did it make any sense?

The falling ash on the skin of the lovers, the kiss in the shower, the deformed faces and limbs, the young girl on the bicycle, the end of the war, the slap in the bar. The repeated slap in the bar. Two slaps, and two quick shots of startled faces turning to look: they are still in a public place. It took so many takes to get right, to synchronize the camera with the actors. She is slapped; she drinks from the glass of beer. By the end she is drunk and crying. By the end she is remembering and forgetting.

Interviewed forty-four years later, a glass of wine beside her on the table, she remembers the pain and the intensity of the work, the abandonment into the character, whose single day became her day every day until Hiroshima was in the can: the long tracking shots, the architecture and the river Ota, the hospital and the museum of shock and awe and suffering.

Walking through the city is not as hard as looking. Looking at the past, looking at the present. The hardest shot to look at in the whole film is an operation on an eye—-pulling open the burned socket, the medical instrument probing. This is a close up but it's in fact a shot lifted from another film—a documentary, which this one is not. This one is a love story, a story of intensity so close to the body it burns away and blows away everything ordinary like happiness or grief or hope and opens an unthinkable future.

Time passes. The lovely face of the passionate young actress in the foreign city has become unrecognizable, even as she talks, even as she remembers.

Gleaning

Etienne-Jules Marey really shot his pictures. He really used a gun, with a barrel for the lens and a chamber with a glass plate that rotated at twelve frames per second, half the speed of film today, as it happens.

Like Aristotle investigating the common ground of animal movement, his chronophotographs analyzed the motion of cats and horses and birds, men running and fencing. *If one of the parts of an animal be moved*, was Aristotle's opinion, *another must be at rest, and this is the purpose of the joints.* The jointed leg, he noted, was *both one and two, both straight and bent, changing potentially and actually by reason of the joint.*

Marey, on his French estate in 1882, built a little stone cabin where, his gun taking images of Aristotle's points about the joints, he brought photography to the brink of motion. To the brink of our delight in seeing things at the same time one and two, straight and bent, potential and actual. To the brink of image mixed with time, coming alive again and again.

The little cabin is now in ruins, but the camera gun is on display nearby, along with the serial images of actual and potential limbs and flying wings. Marey's legacy is tended by his descendants, the Bouton family who are still on the estate. Now the playful digital camera of Agnès Varda reproduces at the touch of a button new traces of his light-writing in time. Long after the moving image has been harvested for commercial value, Varda comes to glean what's left of this early excitement. She follows Marey and Aristotle with her modest instrument, investigating the actual and potential, the straight and the bent, the oneness and twoness of things, and of France.

In the vineyards of Burgundy is a famous psychoanalyst who is also a vintner. His contribution to analysis, he explains to her friendly

little digital lens, is the idea that the self originates in the other. We are what we see, what we are not. She shoots the abundance of France: kilos and tons of unharvested potatoes, apples, grapes, figs, tomatoes; or yoghurt, cheese, fish, meat, bread, past their supermarket expiration dates but still delicious. She shoots waste and vandalism and compassion and inspired scavenging. She shoots the clarity of French law: two lawyers in medieval gowns, one standing among unharvested cabbages, the other among discarded appliances on a city street. Obligingly, they read from the fat red penal code, explaining the oneness and twoness of property: the rights of the left behind since the sixteenth century to take what's left behind.

She frames the rotten, the rejected and the saved. She lingers on friendliness in a trailer park, in a shelter, by a dumpster. She lingers on souvenirs of Japan, and on her own hand: the folds, the lines and spots, the coded expiration date. I am an animal I do not know, she says, shooting the hand that films, that seeks self in the other. Her gleaning shows the happy surprises of a heart-shaped potato, a long-lasting marriage, a clock without hands, the inventiveness of art, the generosity of the poor.

She leaves us with a final gleaning from the slow storm of her aging: standing in the first gusts of a storm, holding a painting of gleaners in a field hurrying before a storm. This is a mental trick called *mise en abyme*, an image of what we are seeing inside what we are seeing, so we also see that we too are part of it, we too are hoping not to be swept away before the gleanings are given form. There is no still point; instead the past, the present, and the possibility of shape itself rise over and over out of the abyss, full of their happy surprises. The immediate cause of animal motion, says Aristotle, is desire, *which arises after perception or after imagination. . . .*

The Dream in the Machine

Smile, though your heart is breaking, says the music, smile under your little toothbrush mustache and your ridiculous bowler hat.

Make us smile, throw your body into the machine, because outside the traffic is rolling by and to keep it rolling the cars have to keep coming off the line. We are smiling now, we are laughing because you are going about the business of being funny, very funny, with the gears and cogs and clocks and whistles and oilcans. The machinery is no match for you, really. It may be laughing too: while you jerk and twitch and take the buttons on a dress for bolts that need tightening, the machine is starting to smoke and pop and stall. The great monster wheels slide and turn into art; they are mocked and parodied; your surprised face leans out of the gears and they become nothing but design and overdesign—or sprockets waiting for the film.

In a government documentary that comes with the *Modern Times* DVD, the factory women work steadily, putting cereal in boxes, wrapping packages of crackers, stitching and cutting, gathering piles of finished hosiery. They fold the sheets, stuff the seat cushions, move small objects onto conveyer belts. In the ideal world of mass production they have large well-lit spaces in which to sit row upon row doing the same thing minute after minute, hour after hour, day after day. The machinery works smoothly. On their breaks they go out for fresh air, talk around the fountain in the washroom. That is when they smile.

You go out and get arrested or lost in the crowd or mistaken for a Socialist. Actually, you may be a Socialist but you are also a daredevil, a graceful skater, a wild improvisatory singer, a human cartoon; you seem to have rubber legs. Bigger men are no match for your physical wit. They blunder and push and shoot and grab but you are the one who gets free and also gets the love of the pretty girl.

The factory girls are wearing uniforms and caps. They move quickly in the rhythm of the enormous machines. There are so many of them and so many boxes of cereal and cigars and lollipops. The stuff shoots out of the machines and out of their lives. We, however, are still eating and smoking and sucking and crowding the busy streets where a little man in baggy pants and clown shoes is moving through the

machinery of modern life and modern times—but just now we are
laughing because all the things we wanted to buy are flying away and
we are free of them and of their cruel industry and also, because of his
undying art, of ourselves.

Possibility

FROM THE KITCHEN WINDOW of this temporary flat I can see the square, identically curtained windows of a hotel. I believe a low budget hotel—the kind of thing strewn along the interstates, clean and predictable and perfectly adequate when the main issue is getting from point A to point B and night intervenes. This one is in the city, however, and the morning sun lights up its uninspiring surfaces with the promise of new experience. Or that's what I imagine for the people behind the curtains, waking up to their day of being somewhere else, somewhere really good, at last.

The first time I noticed these people, a man was standing at an open window holding something to his eyes. I thought it was binoculars, a curious neighbor like myself only optically enhanced, and more unabashed. Then I realized it was a camera and he was probably getting a shot of Coit Tower, which I can't see from here. What I can see is the bay, and Alcatraz, with its perpetually winking light from the observation tower, and a few insignificant clouds over Angel Island. I would never dream of trying to photograph the immensity of air and water, and in the distance the hills of the East Bay (I, too, am waking up to somewhere really good, at last).

My near focus is the back of this budget hostelry and a maid cleaning one of the identical round tables that are the only furniture in its rooms visible from my angle. These glimpses of life are rare and seem important: the boy pulling back the curtains one early morning, a loose end in the thread of his family's narrative: a visit to the beautiful city, the child up early and excited to check things out. Or the two Asian women packing small bags—what was their day going to be? Maybe this is pretty sparse material for a story. Not at all like in Hitchcock's *Rear Window*, when this kind of privileged observation netted a whole world of ongoing stories: struggling artists, urban loneliness, and most exciting of all, murder.

Obviously I'm not looking for murder. As Samuel Johnson pointed out in 1765 (*General Preface* to the plays of Shakespeare) what is pleasurable to watch on the stage would not be at all fun to have actually happen in front of your eyes (murder is precisely the example he used, by the way—murder and treason). The faculty of enjoying a fictional event is a gift we are granted as part of being human and it doesn't mean we want fictional disasters in our mortal lives. On the other hand, fiction, fiction's possibility, does affect that mortal life, giving it a little lift, as if there's some magic to it just behind the logic of one foot in front of the other. The poet's function, says Aristotle, isn't to describe the thing that has happened, but a kind of thing that might happen—a probable possibility that thrills by its nearness to ordinary life.

Take Coit Tower, for example, put up after the fact to mark the reception point of early telegraph messages about arriving ships— it's a monument, in fact, to *im*probability turned possible. It happens also to be a point where you can get a remarkable view if you make the climb, but at a distance it cries out for the heroic photograph, doesn't it? The grade of the street in front of my rear-windowed apartment presents the improbable reality of a fear-inspiring tilt toward Columbus Avenue, but up ahead is that tower against the sky, the dramatic climax of another unlikely slope, a hillside ranged with white houses rising somewhere in the near distance.

As a matter of fact, it's almost the view in another bit of Hitchcock fiction: from in front of Scotty's apartment in *Vertigo*. It's almost the view that led Madeleine (who isn't really Madeleine, but Judy from Salina, Kansas, but when Coit Tower is mentioned in the movie she's playing Madeleine, or rather Kim Novak is and Scotty of course is Jimmy Stewart) oh yes, it's how Madeleine guides herself back to Scotty's place to leave him a thank you note for rescuing her after her jump into the bay, which was actually the most elaborate con, a completely improbable set-up, but made to appear perfectly possible, and so seamless that in the second part of the film when we are shown the seams they just become part of the story too, ratcheting our pleasure up in a way undreamed of by Samuel Johnson, until we are thrust out of the narrative by the shock of the ending.

Coit Tower from this perspective teases my sense of reality; the angle keeps nudging me back into the world of the movie. Then I discovered that indeed that very apartment in front of which Scotty and Madeleine begin their relationship—really begin it, two people going somewhere, not just wandering or one tailing the other—was close by, and one afternoon I went to see if I could find it. It had to be on a street where the impossible slope requires parking at right angles, and a block away on Lombard Street was such a spot. Also, according to the camera placement, it had to be very near the corner, on the left as you descend the hill, Scotty following Madeleine's car as she wanders around his neighborhood and ends up pulling into a spot in front of his own house. So I walked up the street a bit, turned around, and there it was. Coit Tower in exactly the right position and, hidden behind two immense and brilliant evergreens, there was the little front porch with the railing and the mail slot in the wall—the exact spot, unmistakable.

And so different, so not the fiction. It's not just those big evergreens, which were little starter bushes in 1958 and you don't even notice them in the movie. The whole set just looks so much smaller. The camera lens opened it up, gave the place more possibility, plus Kim Novak in that white coat with the black scarf, leaning first

against the wall and then against the railing with the open street behind her. On this little porch there hardly seems room for both the actors, and it appears closer to the street, and the colors are all faded (except for these unwelcome trees, which have had four decades to take over the scene and are now distractingly floodlit by the western sun). Still, there it really is: mortal and unrestored, much like myself.

Watching the movie again, watching the jumping-into-the-bay sequence at Fort Point under the Golden Gate bridge, with that huge brick armory or whatever it is at screen left, and the magical golden-red bridge spanning across the sky to the far hills of Marin and the little figure of the actress (or her double) about to leap off the edge, it's hard to say whether the film is actually more exciting than the mortal effect of being there. Today there's a thick chain hung at the water's edge to dissuade the public from jumping, and anyway the rocks below would make what happens in the movie impossible. Besides, they did that part of it in a tank in the studio.

But the spectacular camera angle—*that* you can make happen with your ordinary eyes. The huge brick structure now has growing on it a lichen that matches the bricks, giving the building a texture mysterious in its reality, in its contingency, in the way it shows what fifty years and coming up close can do. Shooting with the camera here is just manipulating a humble technology, like that man in the hotel

window doing homage to Coit Tower. The place itself, though, the place is magic you can walk in and out of, an Escher drawing in which life and art can't be seen at the same time and also can't be seen except as they give shape to each other.

ACKNOWLEDGMENTS

The many parts of my life that have gone into these essays make it a challenge to trace particular debts—for inspiration and critique, for encouragement and opportunity. Editors whose support has been invaluable, and whose hand has made these essays better are, David Hamilton, David Lynn, Willard Spiegelman, David Weiss, and especially Christina Thompson. The editors at Sarabande Books first offered their generous enthusiasm, and then put the finest, most tactful finish on the collection. Thanks to Max Gimblett for use of the image from his *Oxherding* series that appears on page 106.

I am grateful for the time and space offered by the Lannan Foundation, the Atlantic Center for the Arts, and the San Francisco Art Institute, and to Marianne Stockebrand for the freedom to roam at the Chinati Foundation. Among friends who have read, laughed, questioned, improved, and motivated are Wendy Allanbrook, Read Baldwin, Jennifer Clarvoe, Denis Clifford, Christopher Corkery, John D'Agata, Lydia Davis, Jane Fried, Eva Hoffman, Lori Lefkovitz, Wendy MacLeod, Maria Papacostaki, Peter Rutkoff, Maxine Risley, and Jeri Weiss. My sister Linda Bamber is my essential listening ear, always there for the next note, always sweetening the tune.

To Lewis Hyde I owe all of the above, and more.

Earlier versions of many of these essays were published in the following:

Georgia Review: "Tapping Back"

Harvard Review: "What It's Like in Ohio," "Manatees," "Oxherding in the Chisos Mountains," "By the Pond"

Iowa Review: "Sebald in Starbucks," "My Depressed Person"

Kenyon Review: "The Task of the Translator," "A Writer's Harvest"

Mid-American Review: "Eggs"

Northwest Review: "The Other Side," "Possibility"

Raritan: "Boxes in Texas"

Seattle Review: "Not Exactly Kaddish," as part of a longer essay entitled "After Death"

Seneca Review: "Eye Shadows," "Monkey Mind"

Southwest Review: "Henry Adams in Japan," "Inventing Cinema"

Patricia Vigderman is the author of *The Memory Palace of Isabella Stewart Gardner* (Sarabande Books, 2007), bringing the world of a century-old Boston museum and its eccentric founder into harmony with present reality. Other efforts to reconcile life's discordant notes have led her to the ruined monuments of antiquity and its beautiful salvaged remnants, to an unexpected love affair with film, and into the endlessly unfolding mysteries of nature, language, art, and love. In 2010 she was a Literature Fellow at the Liguria Center for the Arts and Humanities in Bogliasco, Italy. She lives in Cambridge, Massachusetts, and Gambier, Ohio, where she teaches in the English department at Kenyon College.